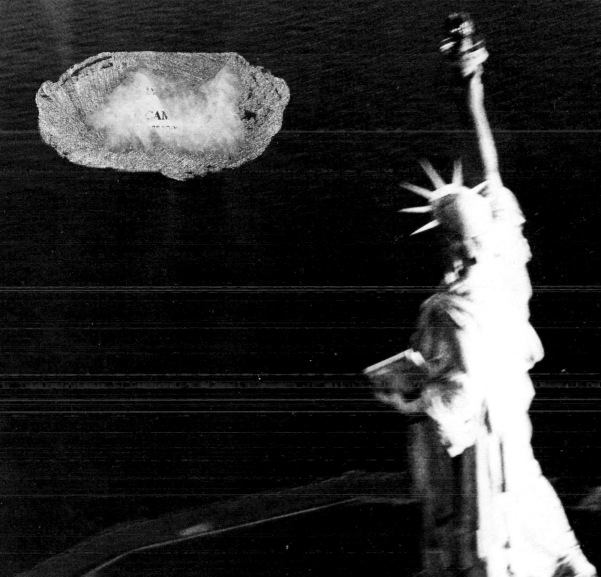

AMERICA

ANDY WARHOL

HARPER & ROW, PUBLISHERS, New York

Cambridge, Philadelphia, San Francisco, London, Mexico City, São Paulo, Singapore, Sydney

For information address Harper & Row
Publishers, Inc., 10 East 53rd Street, New York
N.Y. 10022. Published simultaneously in Canad
by Fitzhenry & Whiteside Limited, Toronto.

FIRST EDITION

Designer: Barbara Richer

Library of Congress Cataloging-in-Publication
Data

Warhol, Andy
 America.
 1. Warhol, Andy 2. United States in art.
I. Title.
N6537.W28A4 1985 760'.092'4 85-42600
 ISBN 0-06-096004-3 (pbk.)

85 86 87 88 89 MPC 10 9 8 7 6 5 4 3 2

America really is
The Beautiful.

ПTENTS

PRE

VIEW

Everybody has their own America, and then they have the pieces of a fantasy America that they think is out there but they can't see. When I was little, I never left Pennsylvania, and I used to have fantasies about things that I thought were happening in the Midwest, or down South, or in Texas, that I felt I was missing out on. But you can only live life in one place at a time. And your own life while it's happening to you never has any atmosphere until it's a memory. So the fantasy corners of America seem so atmospheric because you've pieced them together from scenes in movies and music and lines from books. And you live in your dream America that you've custom-made from art and schmaltz and emotions just as much as you live in your real one.

But what's happened with TV in the last decade or so has really taken a lot of the mystery out of the parts of America that you don't get to much, or maybe never will. Now, with cable and satellite dishes, it's all just there to see every day. The people on the farms can turn on TV and

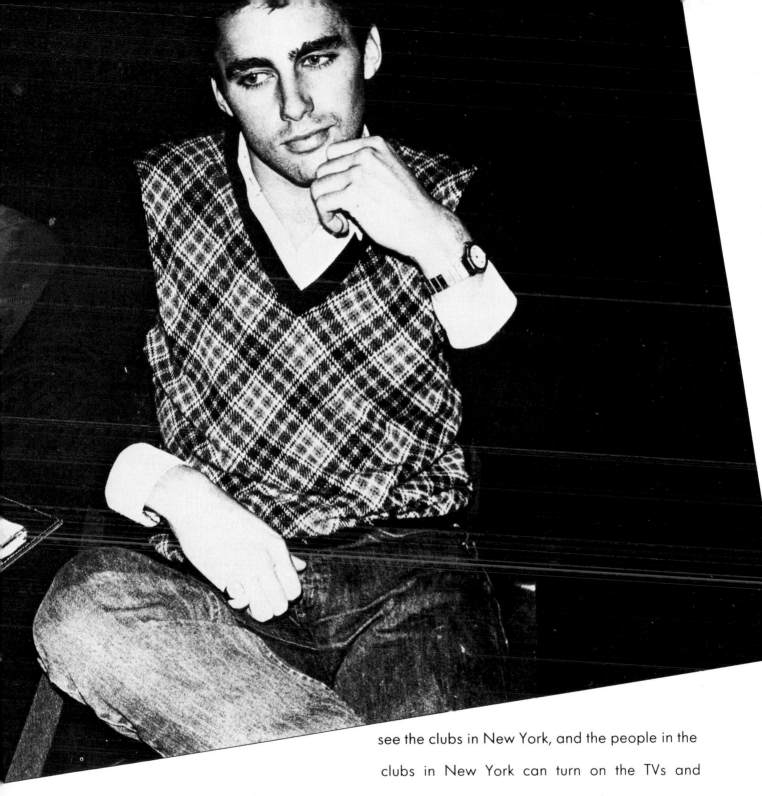

see the clubs in New York, and the people in the clubs in New York can turn on the TVs and watch the grass growing out in the country.

Everybody can see how the other half lives, and maybe all this extensive coverage of every-thing is making people more satisfied to be where they are (it's doing that to me), because now the mystery and romance of the faraway

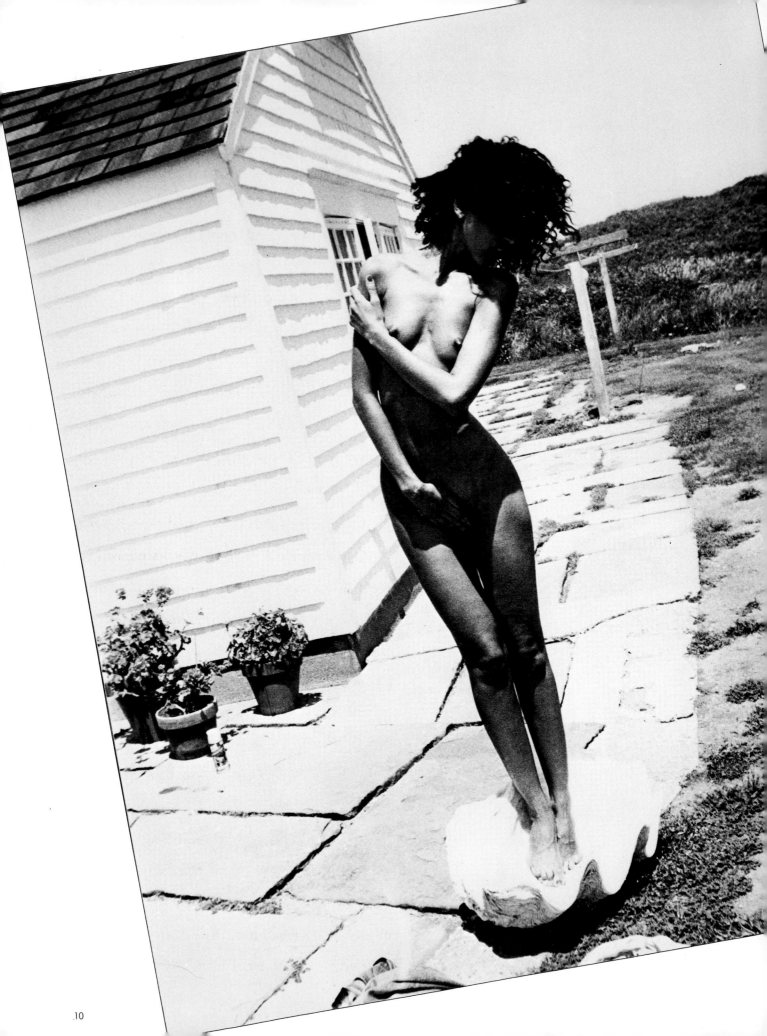

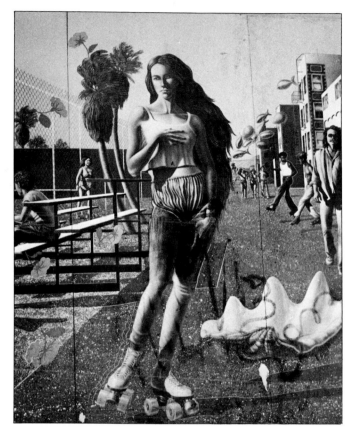

places are pretty much gone. I guess it could work the opposite way too; that it depends on the person and what they've got going for them and how they feel about it.

I'm the type who'd be happy not going anywhere as long as I was sure I knew exactly what was happening at the places I wasn't going to. I'm the type who'd like to sit home and watch every party that I'm invited to on a monitor in my bedroom.

I think the more information you get, the less fantasy you have. Or, maybe with more information, you just have more details to build more fancy fantasies on.

It's the movies that have really been running things in America ever since they were invented. They show you what to do, how to do it, when to do it, how to feel about it, and how to *look* how you feel about it. When they show you how to kiss like James Dean or hook like Jane Fonda or win like Rocky, that's great.

I wish somebody great would come along in public life and make it respectable to be poor again. Because you don't hear about "poor but honest" any more. It's like when you see somebody's poor you think, "They're poor because they couldn't make it in the marketplace," and we put a price tag on intelligence and talent,

which really shouldn't have any. It should be okay to be an impoverished scholar without people wondering why you aren't making money. It should be okay to work on things that they won't pay you for, because that's how inventions happen and things progress.

I keep waiting—like everybody else is—for a really great person in political life. I watch TV on Sunday mornings to look for politicians that I could like, but all I see are guys scared to lose their jobs just trying to talk for thirty minutes without getting fired.

What happened to all that talk a few years ago about repairing the American "infrastructure"—getting people out to rebuild the roads and bridges that are falling apart? A lot of good ideas just seem to fade away. Like in the sixties they were always talking about a new way of living where the entire American work force would be staggered into three shifts of eight hours apiece. To relieve the congestion and make the traffic lighter. So America would be working around the clock, and you'd be getting mail twenty-four hours a day, and the country would never go to sleep. You were going to be able to pick your own work hours. But now, you never hear about it.

With government regulations you can manip-
ulate anything you want. So what I don't under-
stand is why every time an underdeveloped
country starts to get developed, the first thing
they do is manufacture knickknacks and send
them over here. I mean the stuff like musical
toilet paper dispensers and calculator pens.
Who gets them started making these things?
Why don't they show them how to be self-
sufficient foodwise? Because then they wouldn't
have to worry about exporting all these things in
order to make enough money to buy food.

It ends up that we're sending guns and food
to the world, and the world is sending us doo-
dads. And we're feeding places that could be
feeding themselves if they weren't putting all

their effort into making little pieces of junk. And meanwhile, our farmers are using all these drugs in the soil, and the topsoil is getting worn out. I heard that two hundred years ago, there was something like two feet of topsoil here, and today there's only six inches. And when the topsoil is gone, you starve. So what's going to happen when it's gone and all we have in the stores are T-shirts "made in Macao" and radios "assembled in Grenada"?

One of the great things in American cities today is not having all that much money but having so much style that you can get into any place for free. Free parties, free drinks, free food—you just need the right attitude, the right clothes, and being clean. The last is the most important, and ironically, the people who need to freeload the most—the homeless people who live on the streets—don't meet any of these requirements. And it's a bad circle for them because the longer they're out on the street, the crazier and dirtier they get, and the less fit for work they get, so then they *really* can't get a place to live. And they get so dirty from not even having a place to take a shower that they start to smell, even if they've been spot washing wherever they could. And when it gets to that point, they start kicking them out of the restrooms where they've been going to do that little

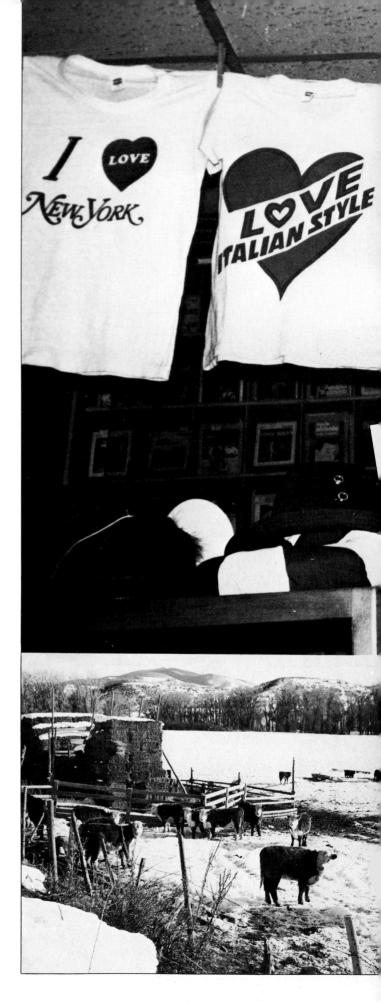

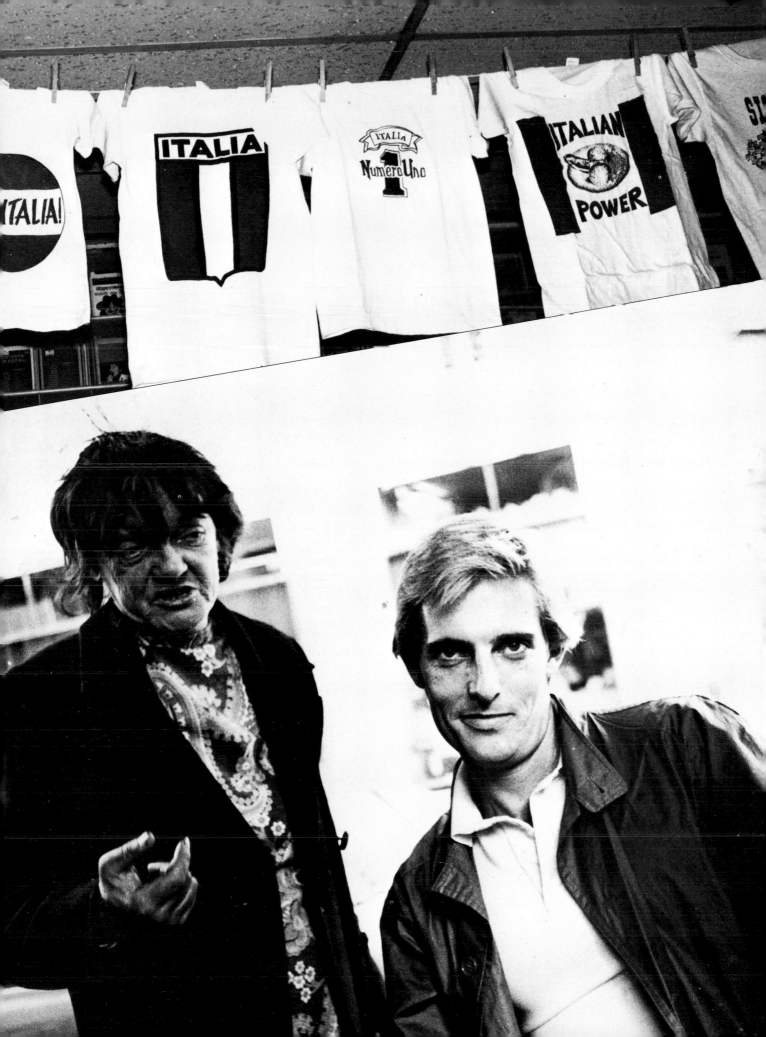

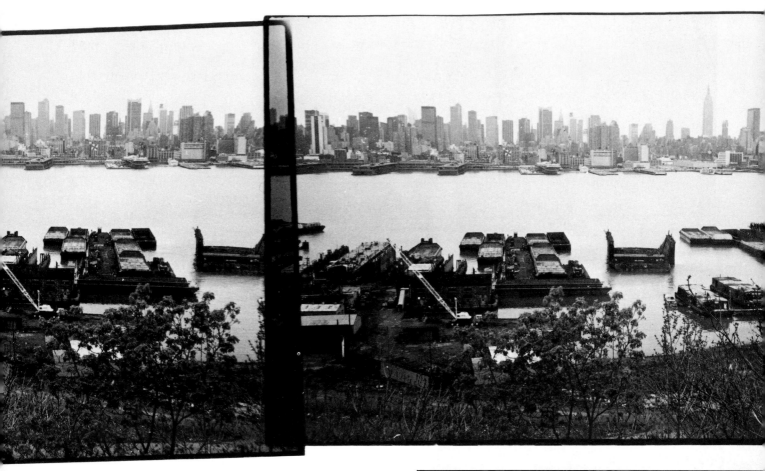

bit of washing—say, in the good department stores. So then they start going to the public libraries, but after a few more months they smell too bad for even the libraries, and they've only got the bus and train stations left, and at that point their condition is about as low as it can get.

This is why I think that the most important thing the government should do for people with no place to live is build huge modern bathhouses where you could go and have both a shower and a washer-dryer to get you and your clothes clean at the same time. And there'd be a time limit, or otherwise people would start living in

there. And they'd be built so you could just hose them down after each usage, and then the people would be clean and back at the point where they can mingle with everybody else again. Because if you can't mingle at all, that's when you really get nutty.

I love that idea of hosing things down—rooms where there's no dusting, no waxing, no vacuuming, just hose it down. I wish they'd build movie theaters with a big ditch in front of the first row so you could just turn on the hoses when the movie's over and swoosh down the sticky floors and sweep it all out through the ditch. Just like a barn.

I know that it's not supposed to be polite to say "America" when you mean the United States. In school they tell you that it's insulting to all the other countries in North and Central and South America when the United States of America calls itself "America," because where does that leave them? But I don't care if Venezuela or someplace gets upset. We're the states who thought of uniting into the best country in the world, and we're the only country that thought of making the word part of our name. Brazil doesn't call itself "Brazil of America." So we've got a right to call ourselves "America" for short, anytime we want. It's a beautiful word, and everybody knows it means us.

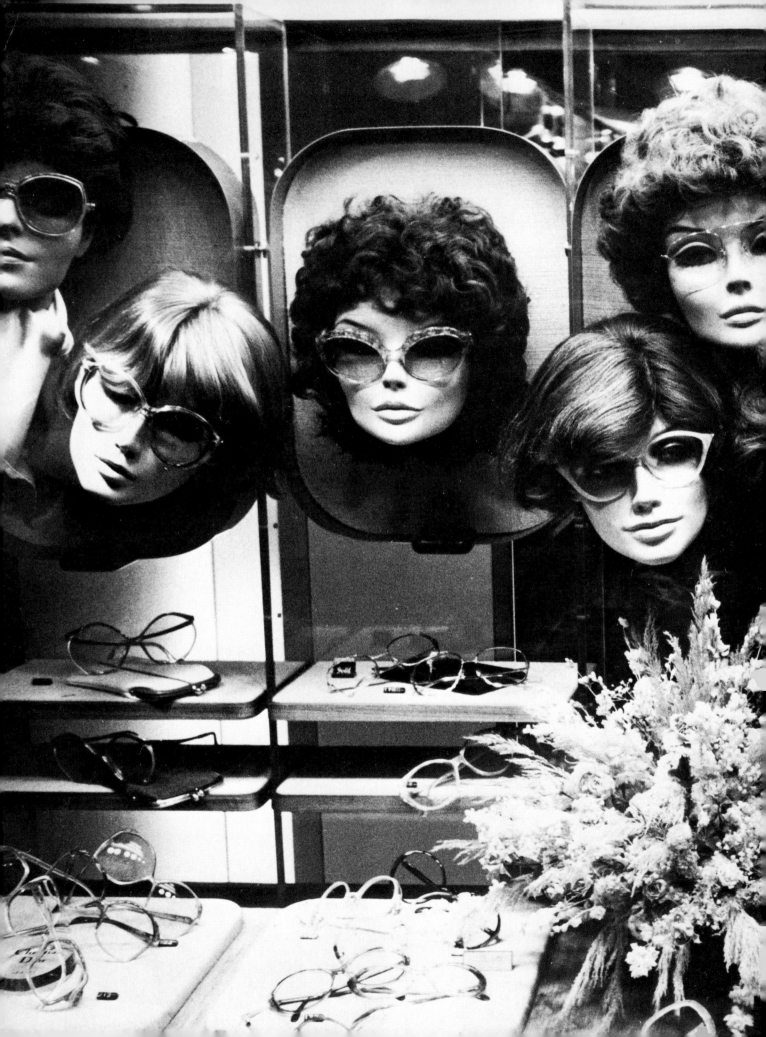

WINDOW SHOPPING

Looking at store windows is great entertainment because you can see all these things and be really glad it's not home filling up your closets and drawers.

And if you don't have much money and it makes you depressed to see all the stuff you think you want, just go to the wholesale districts where the signs say "No Retail" and try to buy something and have the stores kick you out.

Buying things in America today is just unbelievable. Let's say you're thirsty. Do you want Coke, Diet Coke, Tab, Caffeine-Free Coke, Caffeine-Free Diet Coke, Caffeine-Free Tab, New Improved Tab, Pepsi, Diet Pepsi, Pepsi Light, Pepsi Free, Root Beer, Royal Crown Cola, C&C Cola, Diet Royal Crown Cola, Caffeine-Free Pepsi, Caffeine-Free Diet Pepsi, Caffeine-Free Royal Crown Cola, Like, Dr. Pepper, Sugar-Free Dr. Pepper, Fresca, Mr. Pibb, Seven-Up, Diet Seven-Up, orange, grape, apple, Orelia, Perrier, Poland, ginger ale, tonic, seltzer, Yoo-Hoo or cream soda? Do you want

pineapple, papaya, guava, peach, coconut, apple, orange, strawberry grapefruit, pink grapefruit, cherry-apple, apple-strawberry, grape, piña colada, sparkling apple or Juicy Juice? Do you want any of this fresh-squeezed? Do you want one of the fifty varieties of malteds, the twenty kinds of frozen fruit shakes, the fifteen kinds of coffee or the thirty kinds of tea?

And not only are there all these choices, but it's all democratic. You can see a billboard for Tab and think: Nancy Reagan drinks Tab, Gloria Vanderbilt drinks Tab, Jackie Onassis drinks Tab, Katharine Hepburn drinks Tab, and just think, you can drink Tab too. Tab is Tab and no matter how rich you are, you can't get a better one than the one the homeless woman on the corner is drinking. All the Tabs are just the same. And all the Tabs are good. Nancy Reagan knows it, Gloria Vanderbilt knows it, Jackie Onassis knows it, Katharine Hepburn knows it, the baglady knows it and you know it.

When you think about it, department stores are kind of like museums.

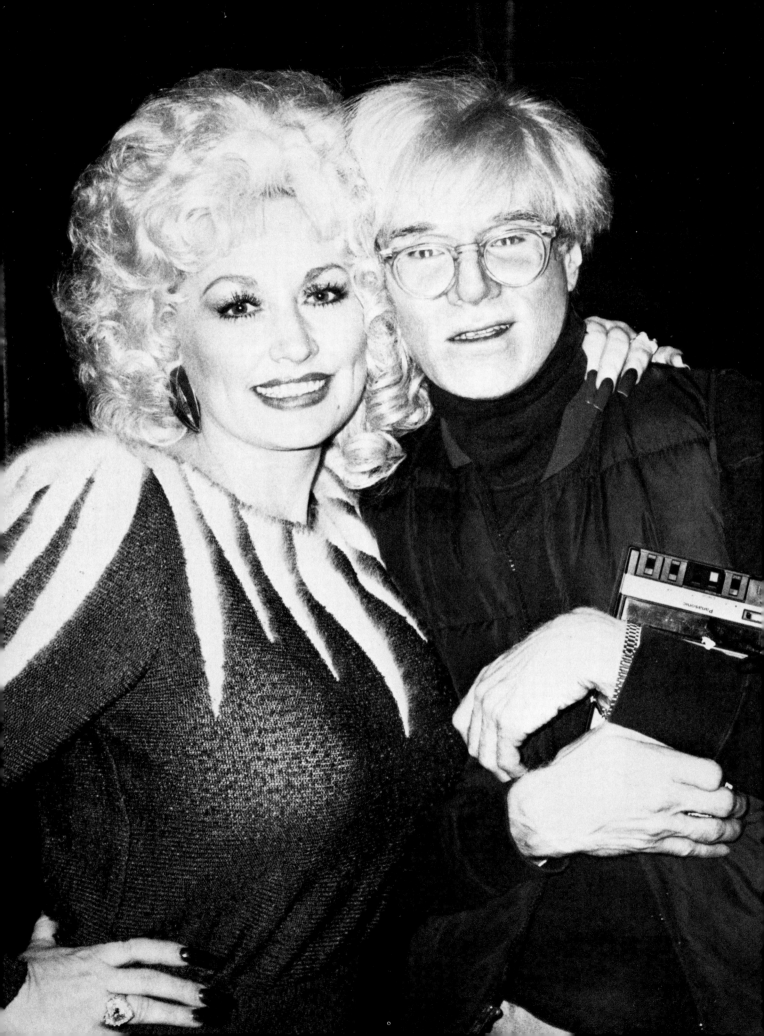

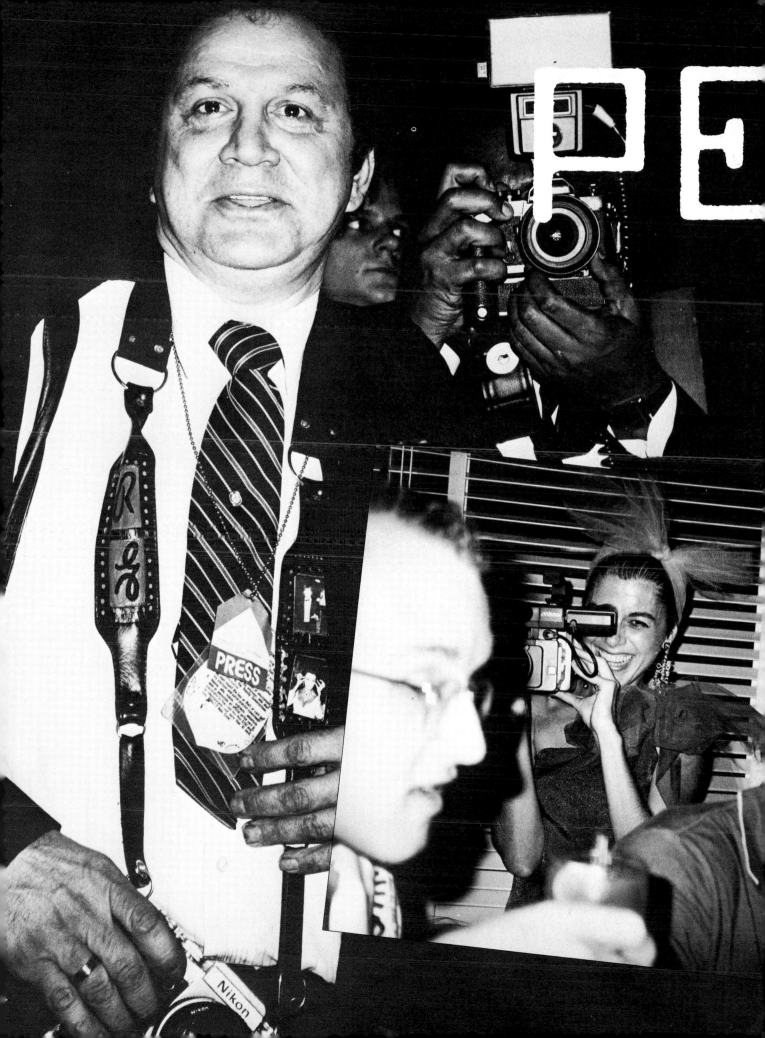

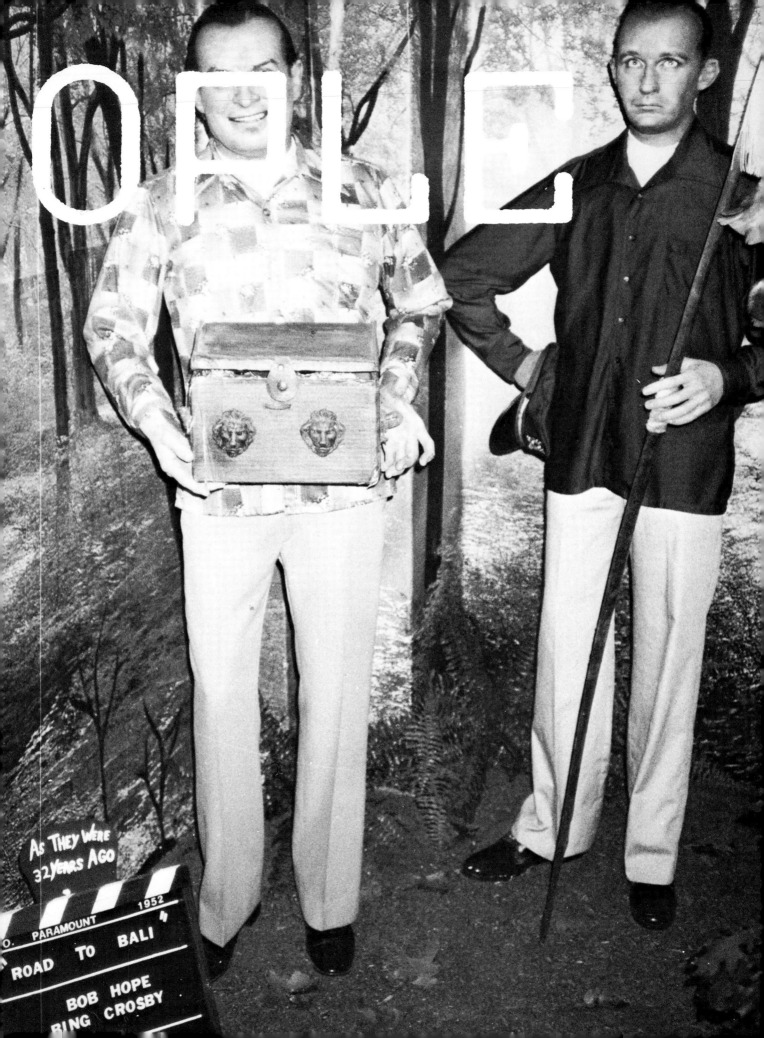

OPLE

As They Were
32 Years Ago

PARAMOUNT 1952

ROAD TO BALI

BOB HOPE
BING CROSBY

There's no country in the world that loves "right now" like America does. I guess so many things are happening today that we're too busy to do anything but look, talk and think about all of it. We don't have time to remember the past, and we don't have the energy to imagine the future; we're so busy, we can only think: Now!

If you don't believe it, just look at all the big American magazines, where the exciting things are only the newest things: the book that was just published, the movies that just opened, the latest records. It gets to the point where we can barely remember what came out before we're rushed on to the next, newer sensation.

It's exactly the same story with news about people, especially famous people. There's always a little bit of sad story: the hard, brutal struggle to the top. There's a tiny bit about hopes for the future, where the celebrity talks about the wonderful things they're going to try to do next. But the real news, the big thing, whether it's in the magazines or the newspapers or on TV, is the Now: What they're doing right now, where they live right now, who they love right now. And as soon as their now gets summed up we move immediately on to another person . . . and another now.

For any part of the media, the person who's getting interviewed always puts on their public,

media personalities. They're always incredibly active, perfectly balanced, gung-ho, well-rounded, vim and vigor kind of people, who only say the things public people are supposed to say: that everything's just great, or maybe things used to be a *little* bad but now they couldn't be better, that living life is wonderful twenty-four hours a day, that they know deep in their hearts that things are always going to get better and better, that their personal story and their work and anything you could think of is just perfect.

But no matter how perfectly someone's got their public personality going, it's never as good as their real life. You never get to hear that some parts of being "successful" aren't so great, or that the "overnight success" took working like a dog all the time for twenty years, or that someone who's doing really well on the outside is working like crazy to overcome lots of problems on the inside.

Clockwise: Cheryl Tiegs, Jane Fonda, Andy, Pee-Wee Herman.

I always wanted to be a comedian. But the nicer I am, the more people think I'm lying.

With people only in their public personalities, and with the media only in the Now, we never get the full story about anything. Our role models, the people we admire, the people American children think of as heroes, are all these half-people. So if you have a real life you can get a lot of crazy ideas from this information. You can think you're a real loser, and you can think if only you were rich or famous or beautiful, your life would be perfect, too.

The media can turn anyone into a half-person, and it can make anyone think that they should try to become a half-person as well.

It used to be that when you were famous, you were famous for one thing. John F. Kennedy was President. Elvis was the King of Rock and Roll. Elizabeth Taylor was the world's greatest movie star.

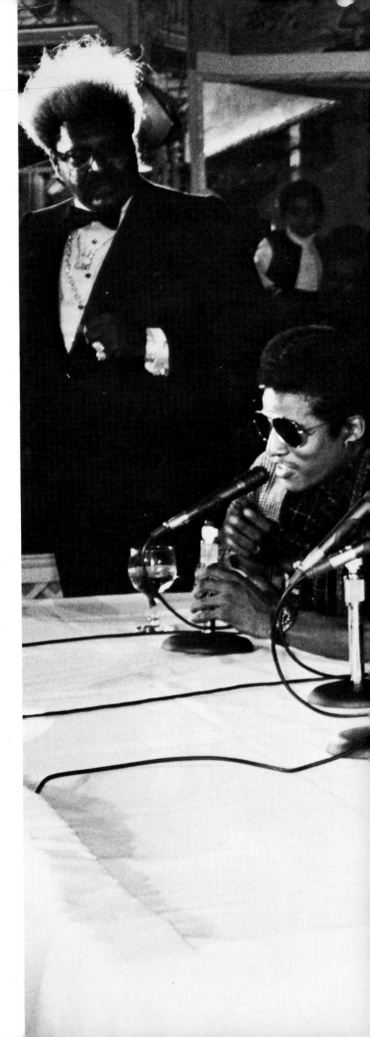

When the Jacksons and boxing promoter Don King had a big press conference in Central Park to announce the tour, the New York police were sure there would be a mob and so they brought in hundreds of cops. But it ended up that nobody came really, so there were more police than audience.

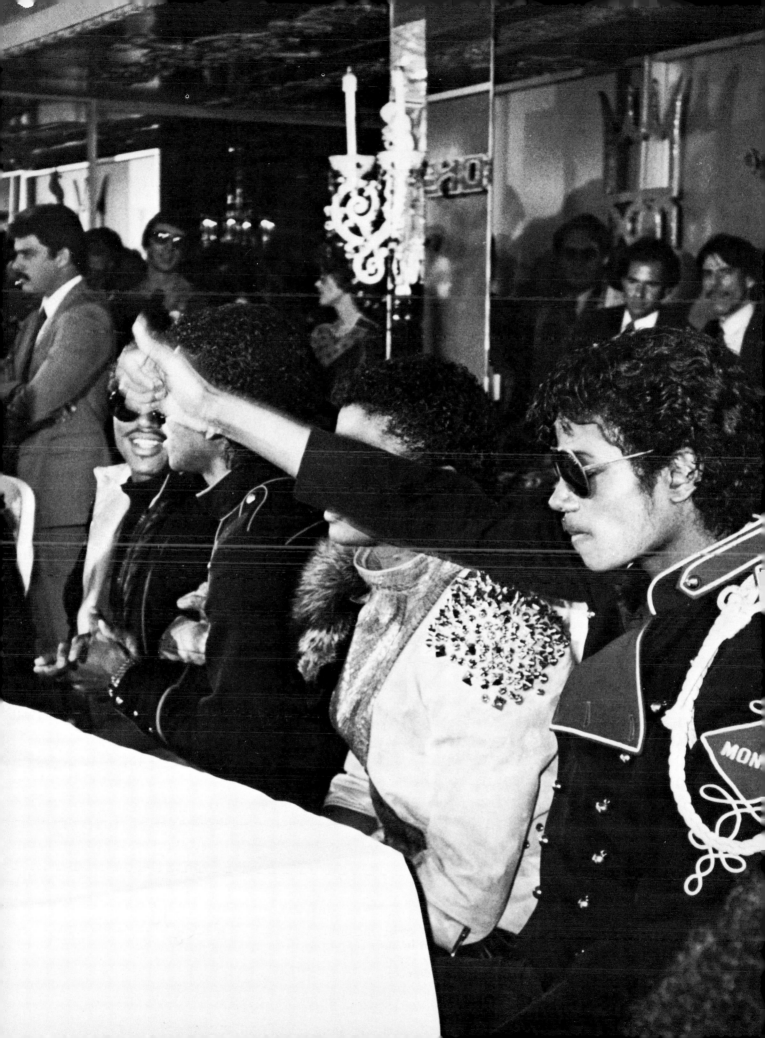

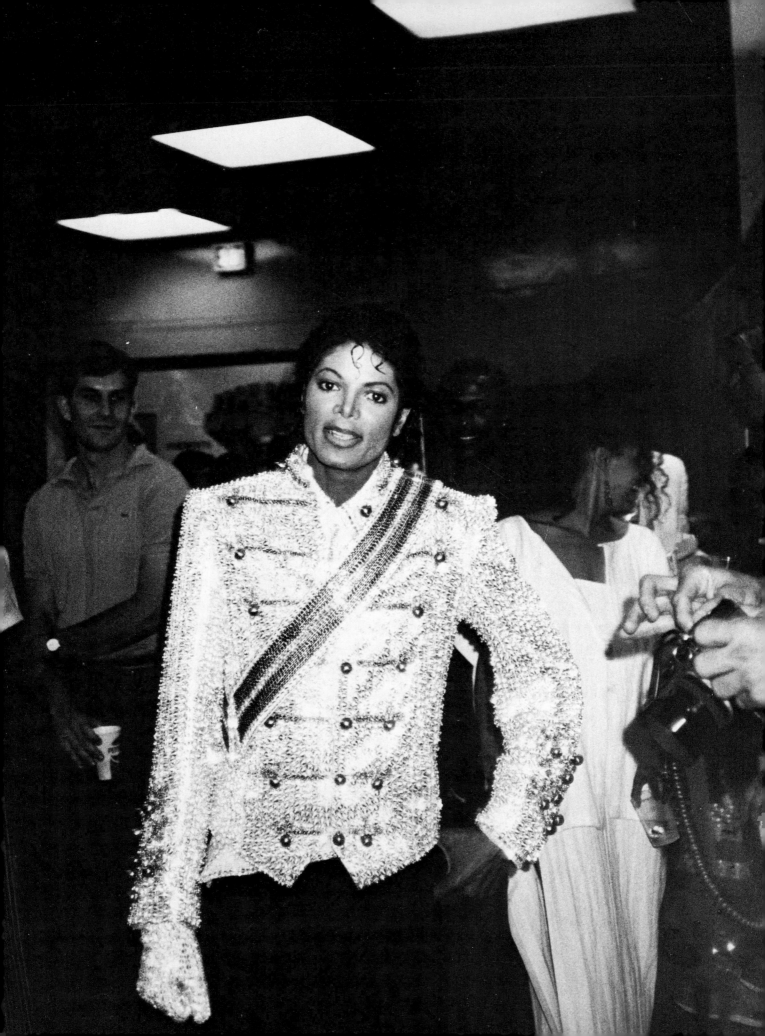

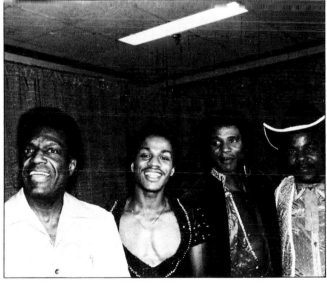

Before and after a great tour: the Jacksons, with Don King, Emmanuel Lewis, Rosy Grier and Nipsy Russell.

But now, it seems like you have to do lots of things really well, and you don't get to stay famous for long unless you're always switching.

Grace Jones is an example of this. First she was a model, then a singer, then a nightclub entertainer, and now she's an actress. Maybe next she'll become a famous businesswoman, and then go on and do something else entirely.

At the same time, there's more media every day: cable TV, satellite TV, new magazines starting up every minute. And with more media, they need more celebrities and more news to have something to talk about.

So the writers and photographers who work for these celebrity media have the worst time. They have to be able to recognize all these different new stars when they see them in real life—and they have to know what the star is up to the last time anyone knew. So when you see the photographers and the reporters at nightclubs and restaurants and movie premieres, you can read their minds: Was that someone I should know? Who's that? Why are you taking their picture?

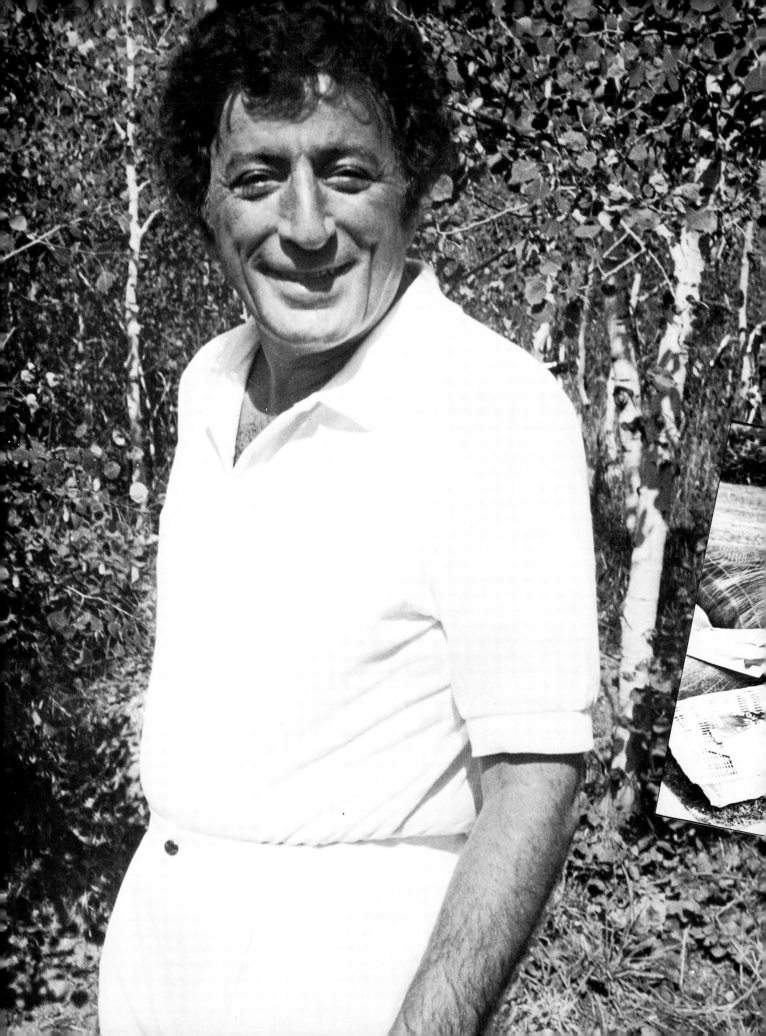

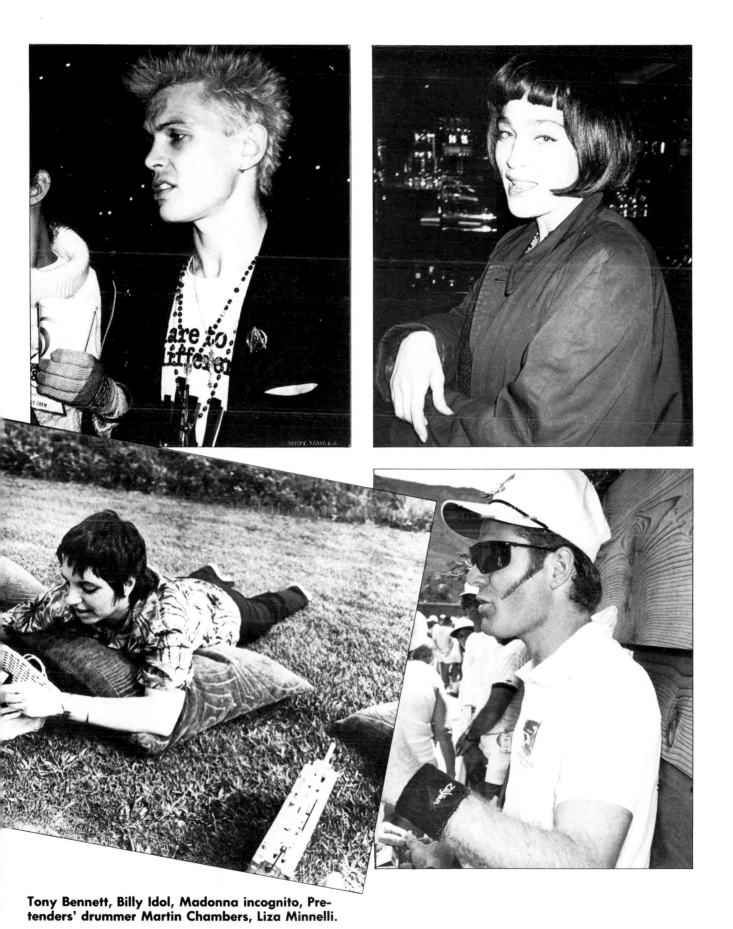

Tony Bennett, Billy Idol, Madonna incognito, Pretenders' drummer Martin Chambers, Liza Minnelli.

Tony Bennett told me that he always wanted to be a painter.

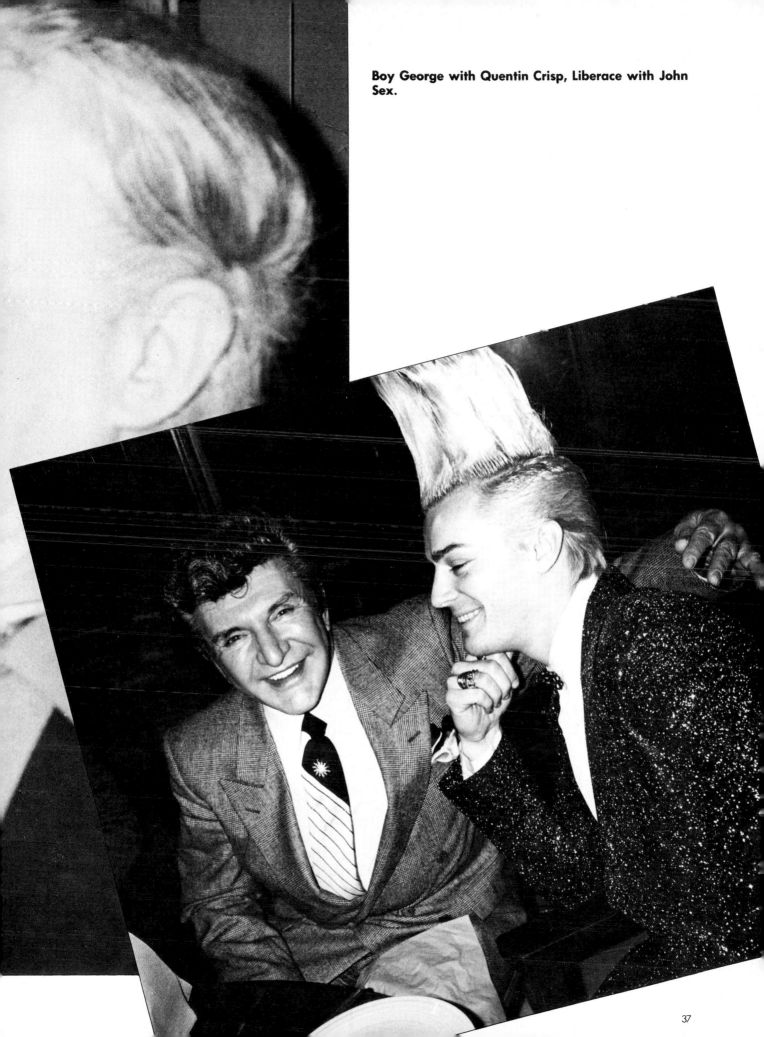

Boy George with Quentin Crisp, Liberace with John Sex.

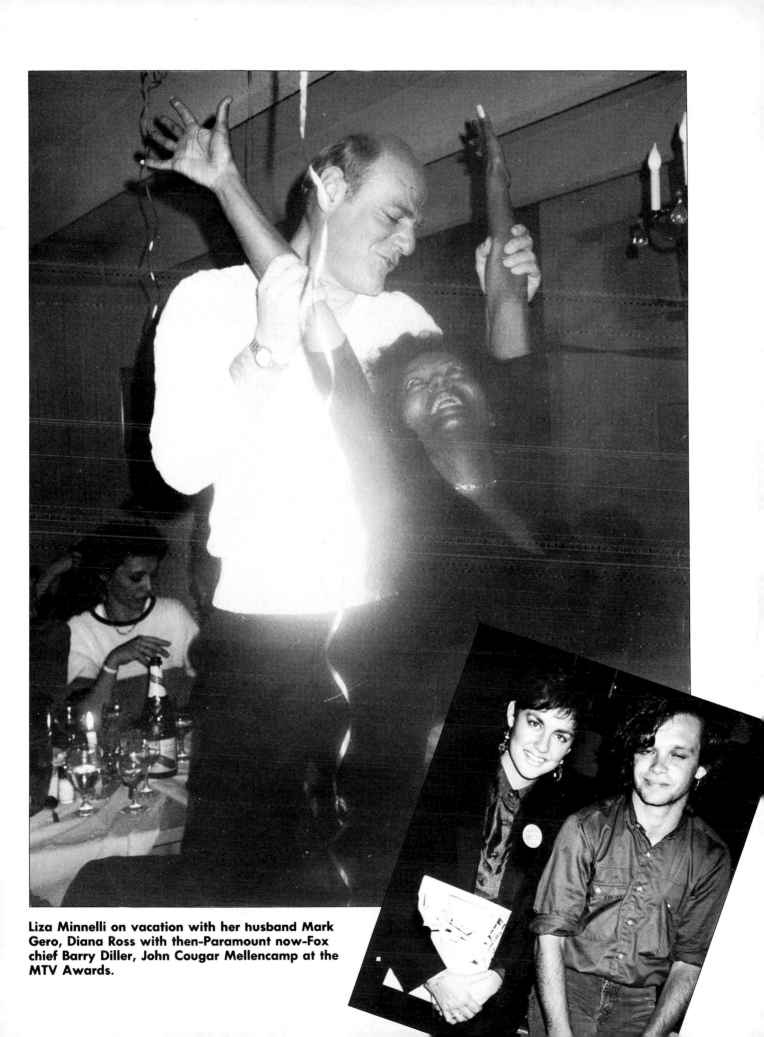

Liza Minnelli on vacation with her husband Mark Gero, Diana Ross with then-Paramount now-Fox chief Barry Diller, John Cougar Mellencamp at the MTV Awards.

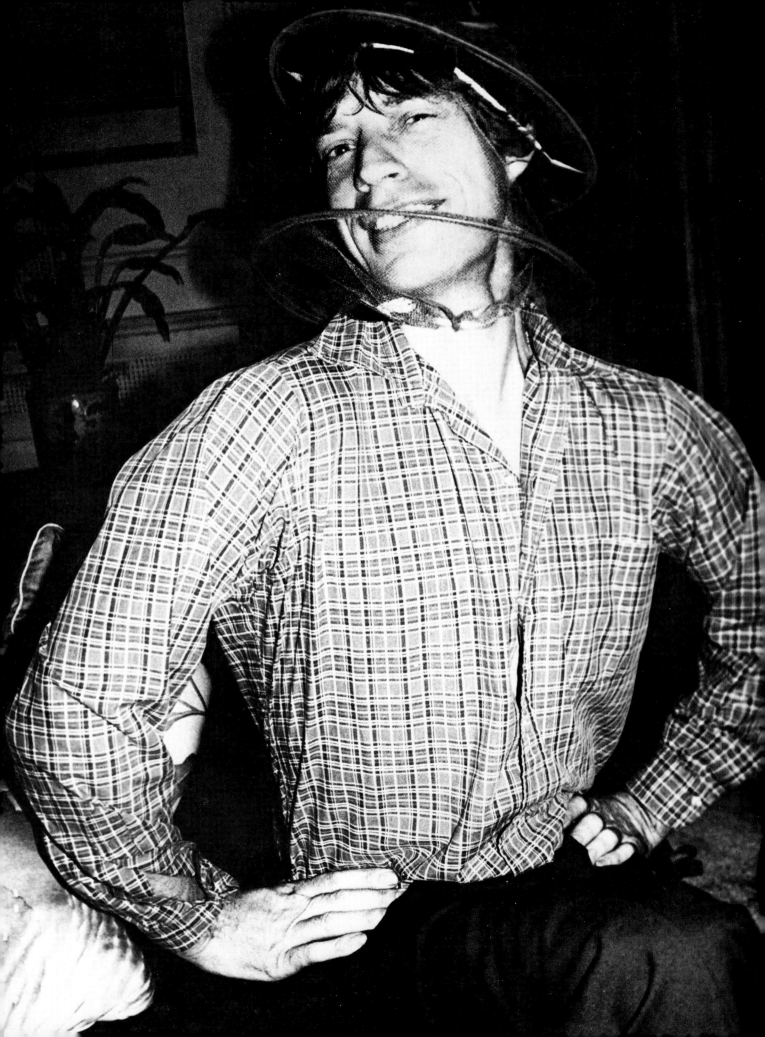

Mick and Jade Jagger, Sean Lennon.

The McGuire Sisters.

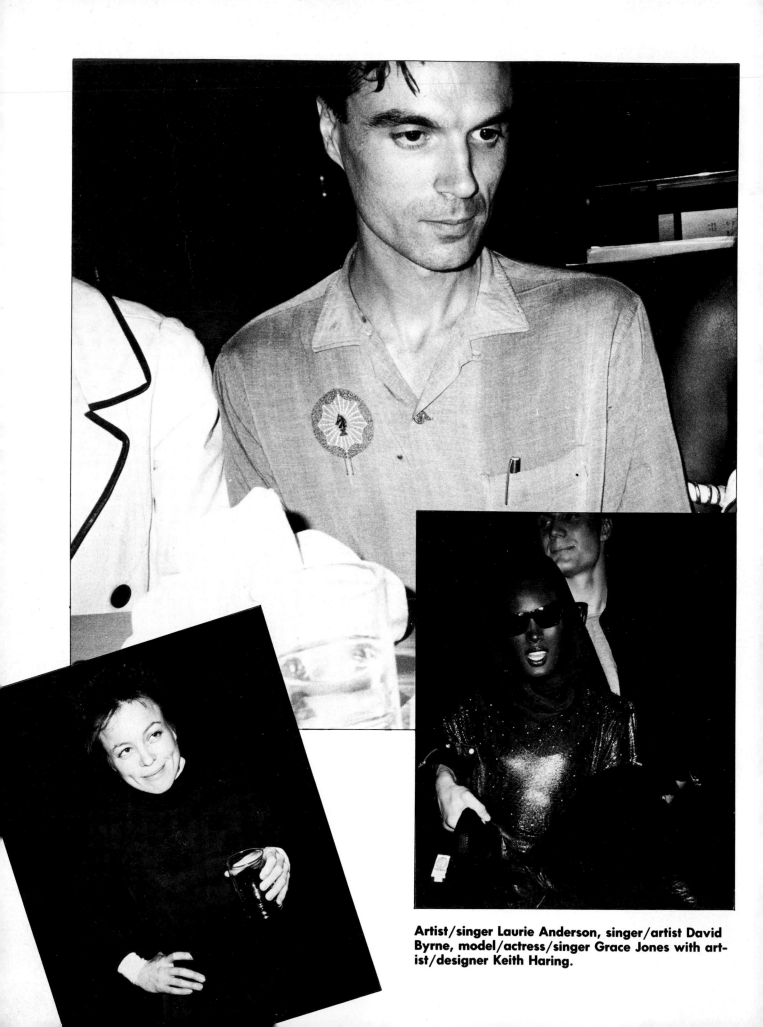

Artist/singer Laurie Anderson, singer/artist David Byrne, model/actress/singer Grace Jones with artist/designer Keith Haring.

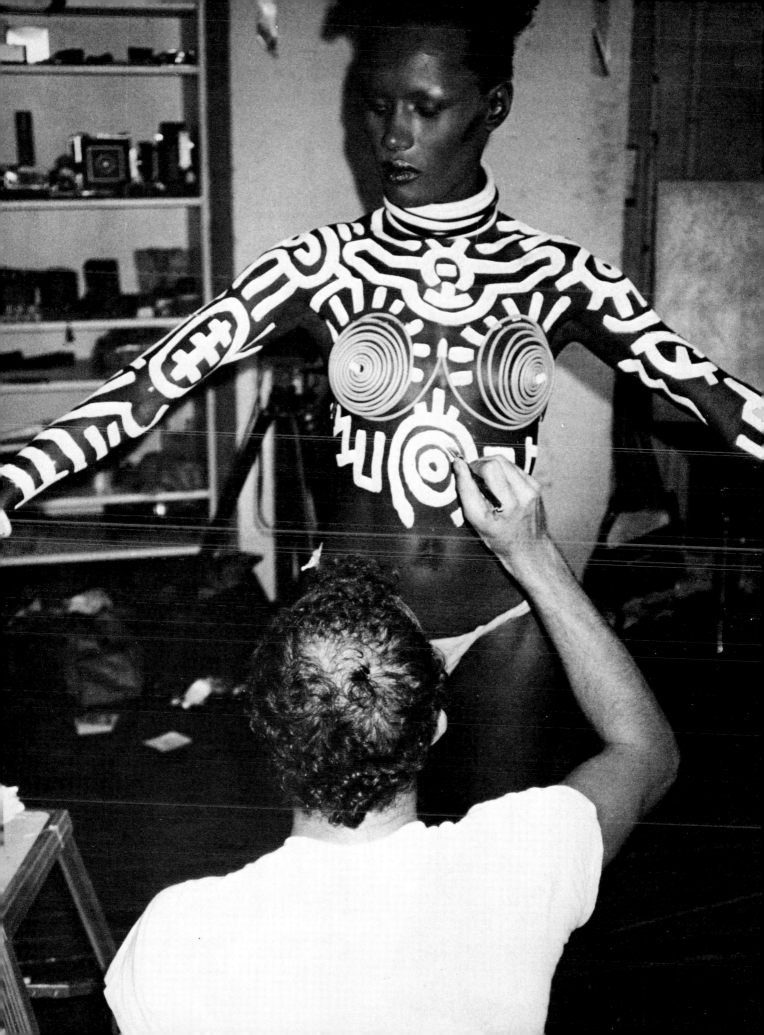

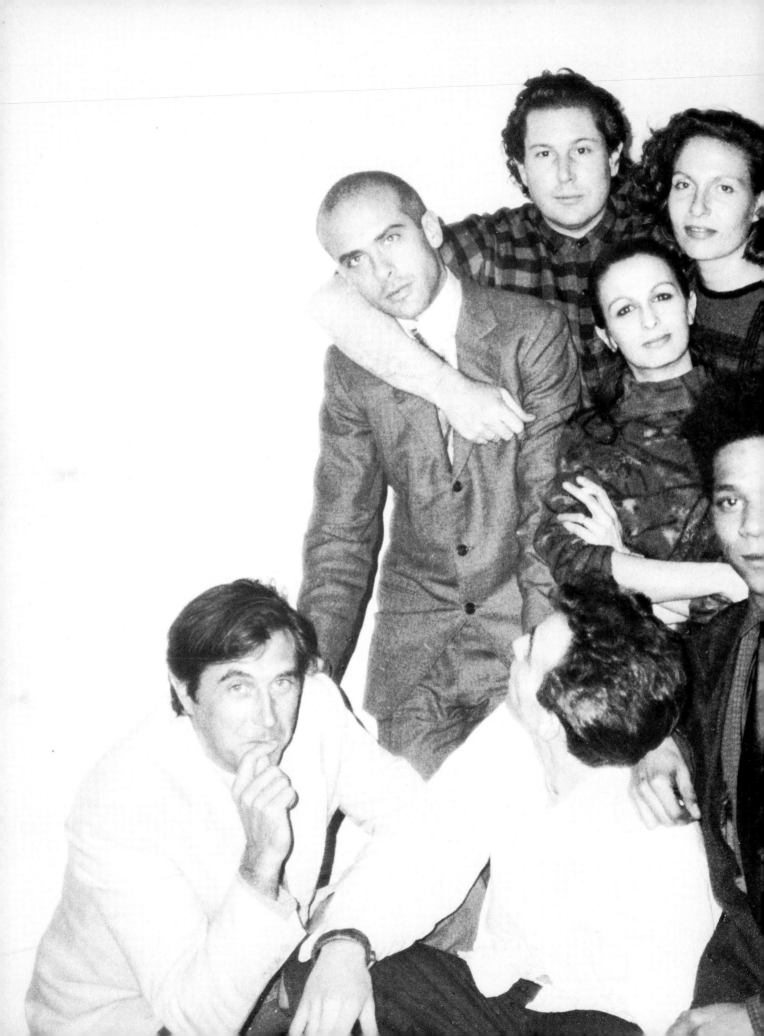

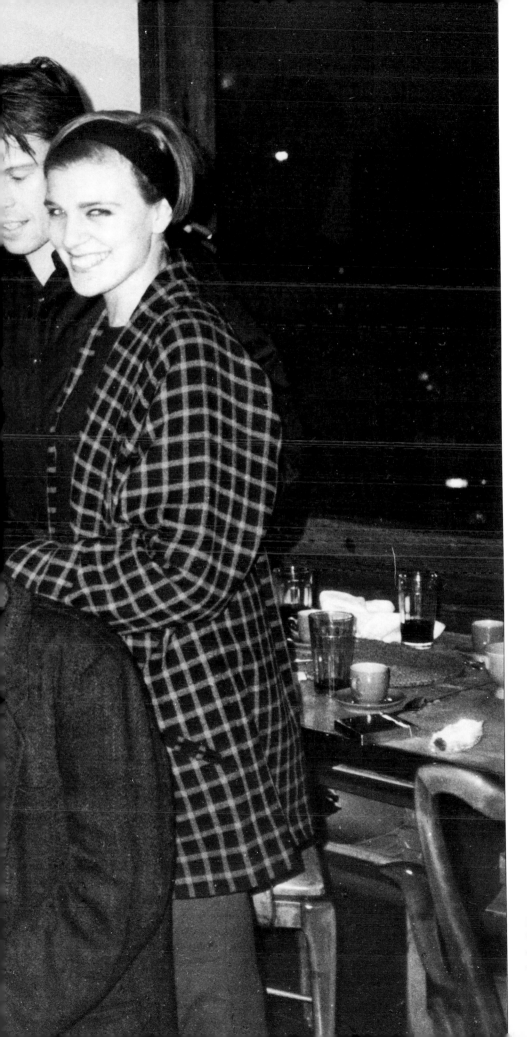

Brian Ferry, Francesco
Clemente, Julian and
Jacqueline Schnabel,
Jean-Michel Basquiat.

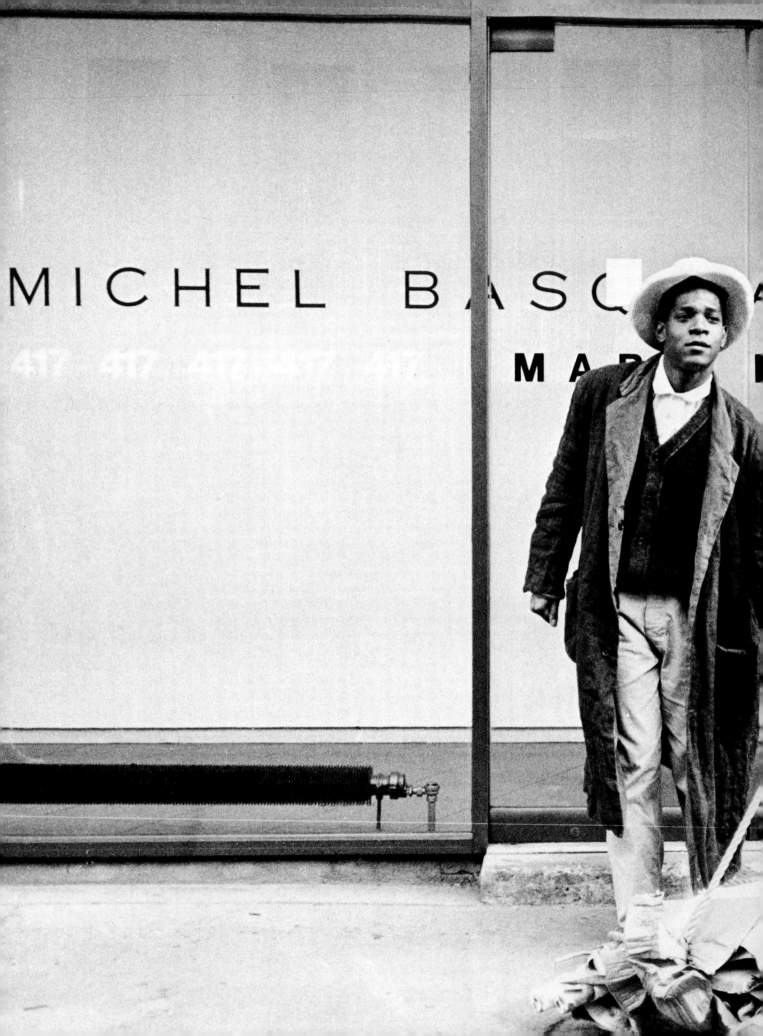

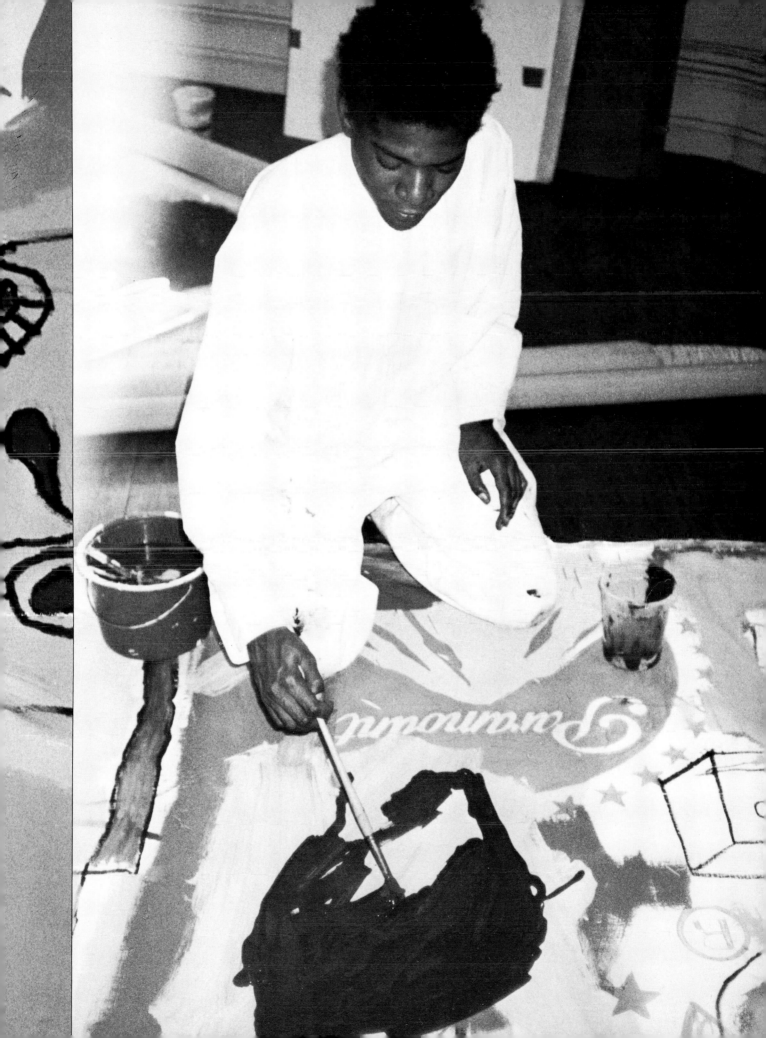

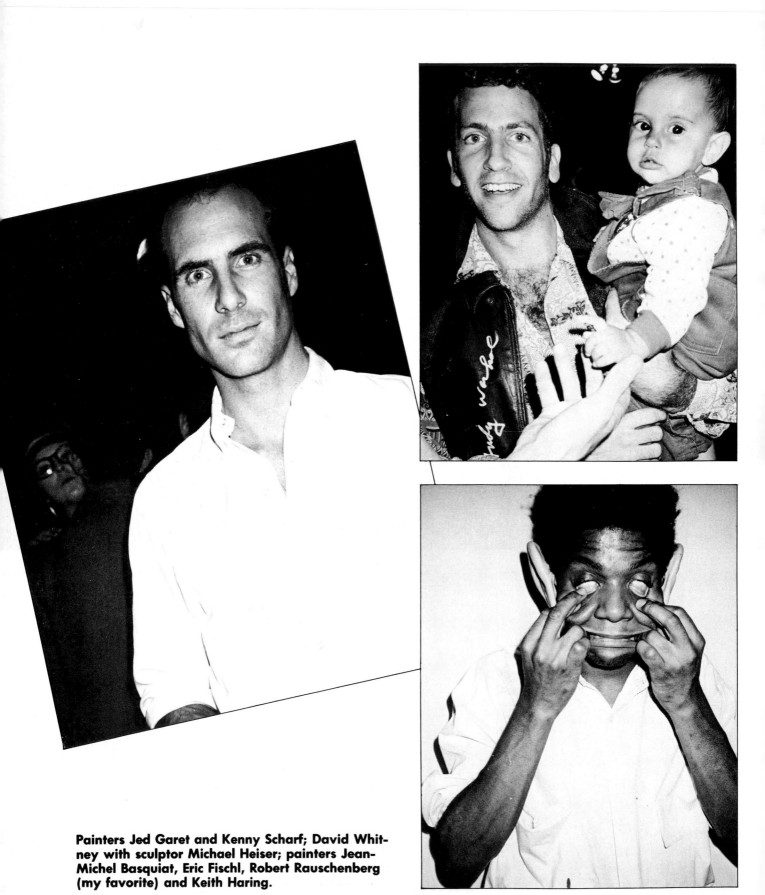

Painters Jed Garet and Kenny Scharf; David Whitney with sculptor Michael Heiser; painters Jean-Michel Basquiat, Eric Fischl, Robert Rauschenberg (my favorite) and Keith Haring.

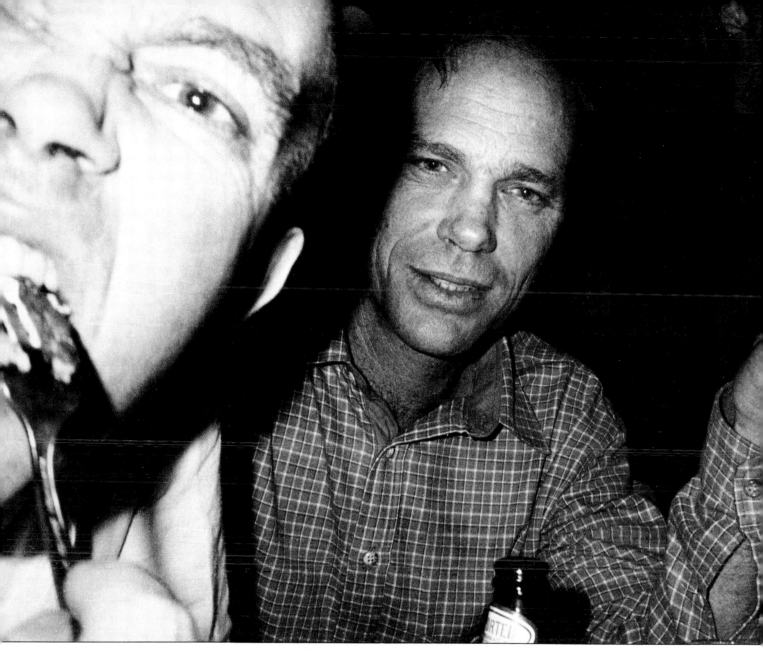

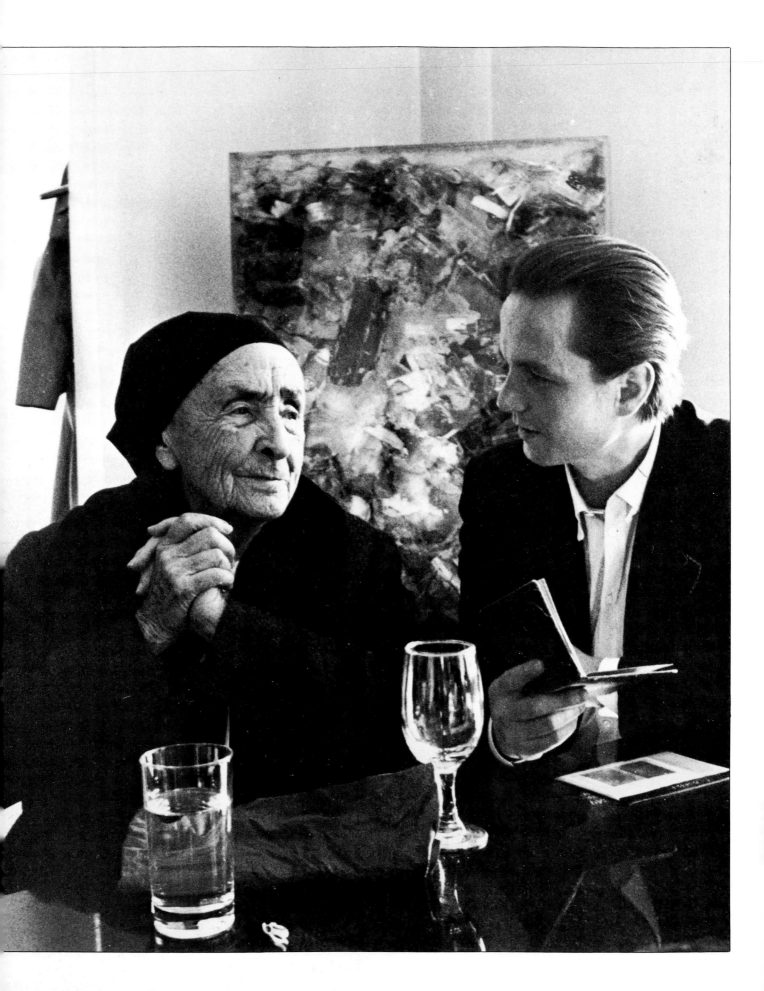

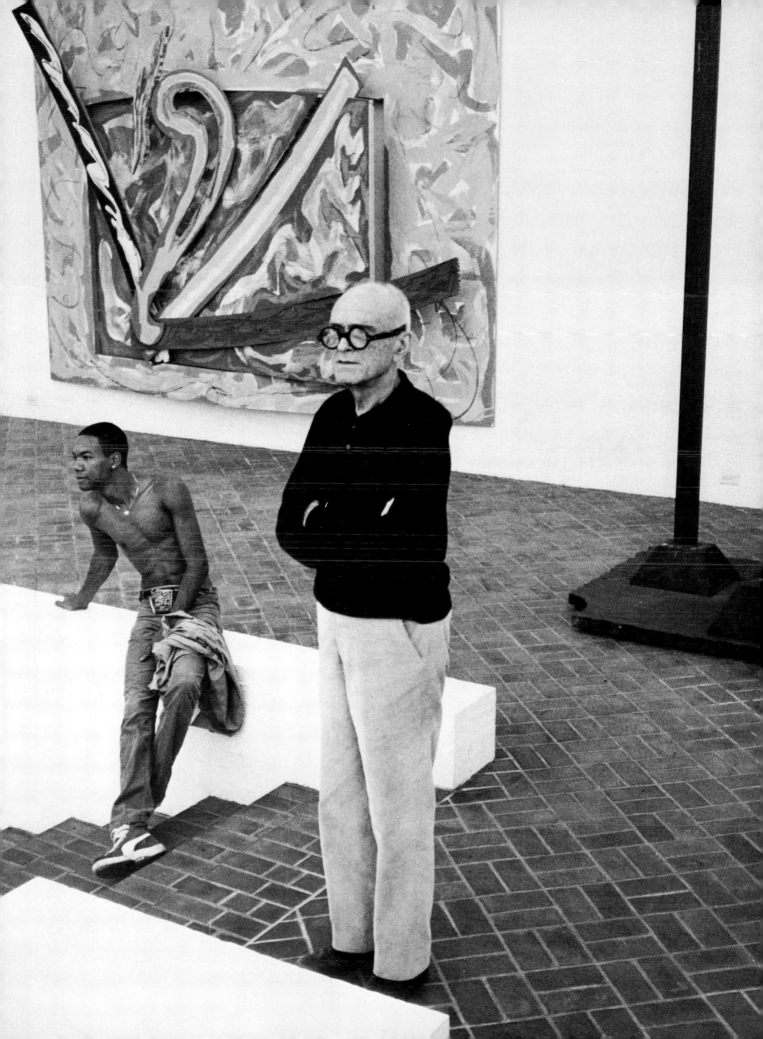

On the preceding pages:
Georgia O'Keeffe; Philip Johnson in his sculpture garden near the Glass House in Connecticut.

On these pages: Edward Albee with Louise Nevelson; Robert Wilson with Christopher Knowles; David Hockney paints the stage.

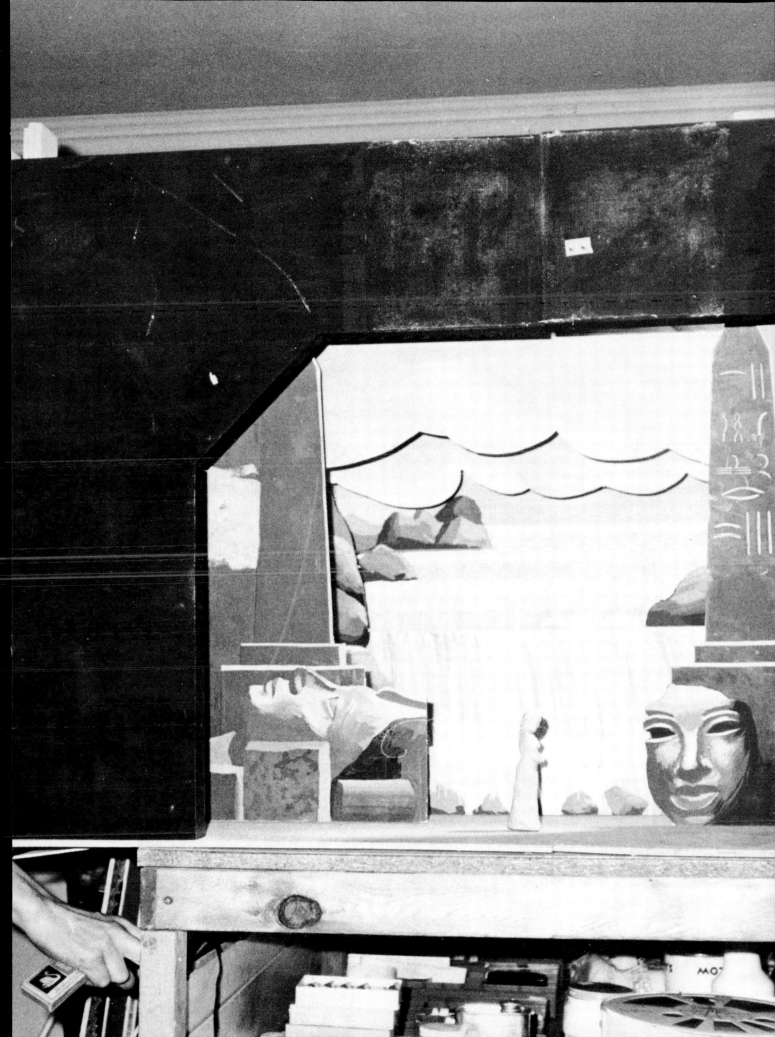

Maureen Stapleton, Elizabeth Taylor, Lillian Hellman; Gloria Swanson.

The other day this girl I met asked me if I'd known Jayne Mansfield. I told her, "Yes, I knew Jayne." And then I thought, "Why am I lying? I never met her in my life."

But I read all these books and articles about her at some point, and I didn't want to disappoint this voluptuous girl because I knew it'd be

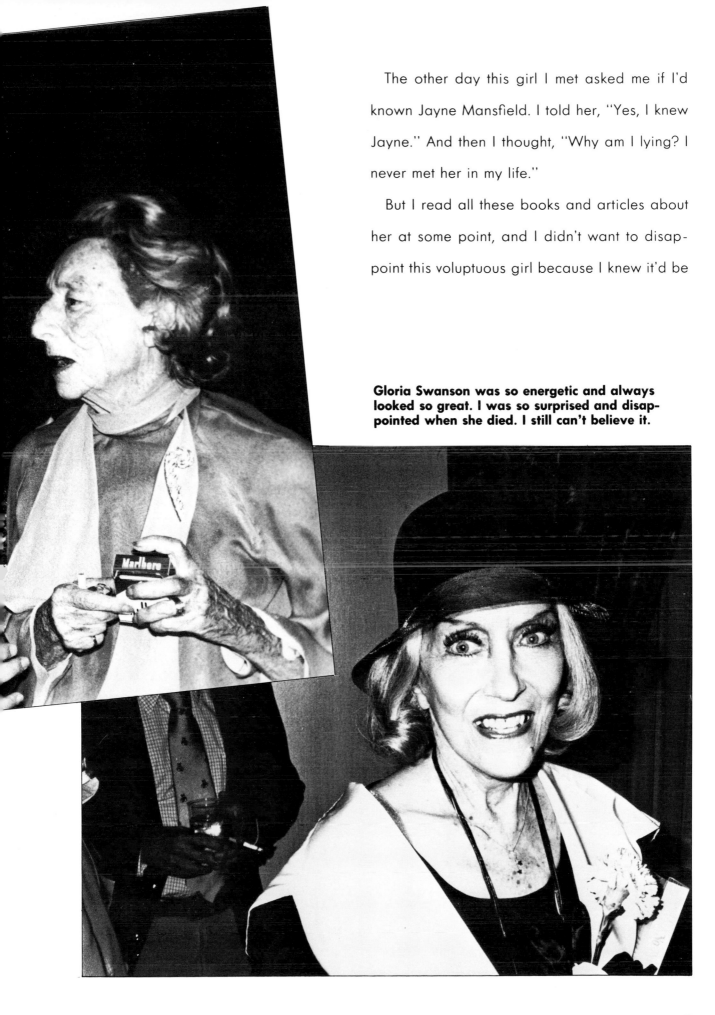

Gloria Swanson was so energetic and always looked so great. I was so surprised and disappointed when she died. I still can't believe it.

more exciting for her to be talking to me if she thought that I'd once talked to her biggest idol.

I think celebrities can be the biggest liars about who they know, because nobody's going to call them on it. Who's going to doubt me when I tell them I met Jayne Mansfield in, say, a boutique on Madison Avenue buying a beautiful pair of gold Capri pants, or in a pharmacy buying some Breck hairspray and a nice, big teasing comb?

Mrs. Yul Brynner, Lillian Gish, Ann Miller.

Christopher Reeves, John Travolta in Houston, Mel Gibson with Mark Lee.

The thing is, if you're a celebrity yourself, everybody *expects* you to know all the great people, and you don't want to let them down. I've met 80% of the people you'd think I've met, and the other 20% I'm dying to meet.

I love it when you ask actors, "What're you doing now?" and they say, "I'm between roles." To be living "Life Between Roles," that's my favorite.

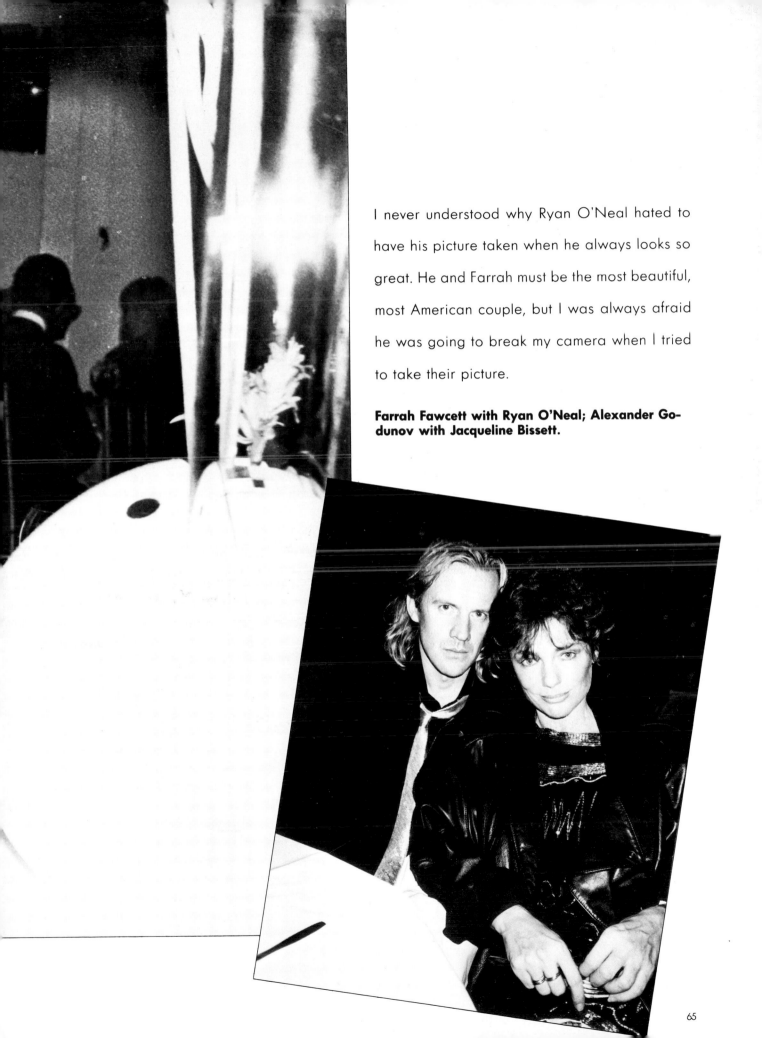

I never understood why Ryan O'Neal hated to have his picture taken when he always looks so great. He and Farrah must be the most beautiful, most American couple, but I was always afraid he was going to break my camera when I tried to take their picture.

Farrah Fawcett with Ryan O'Neal; Alexander Godunov with Jacqueline Bissett.

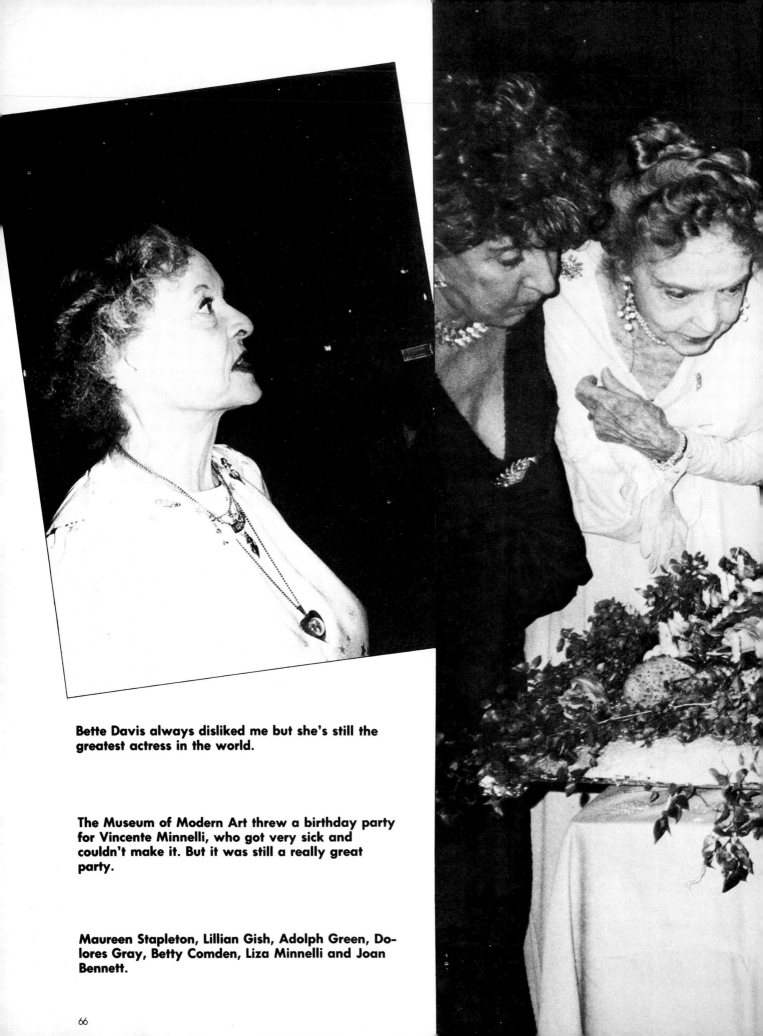

Bette Davis always disliked me but she's still the greatest actress in the world.

The Museum of Modern Art threw a birthday party for Vincente Minnelli, who got very sick and couldn't make it. But it was still a really great party.

Maureen Stapleton, Lillian Gish, Adolph Green, Dolores Gray, Betty Comden, Liza Minnelli and Joan Bennett.

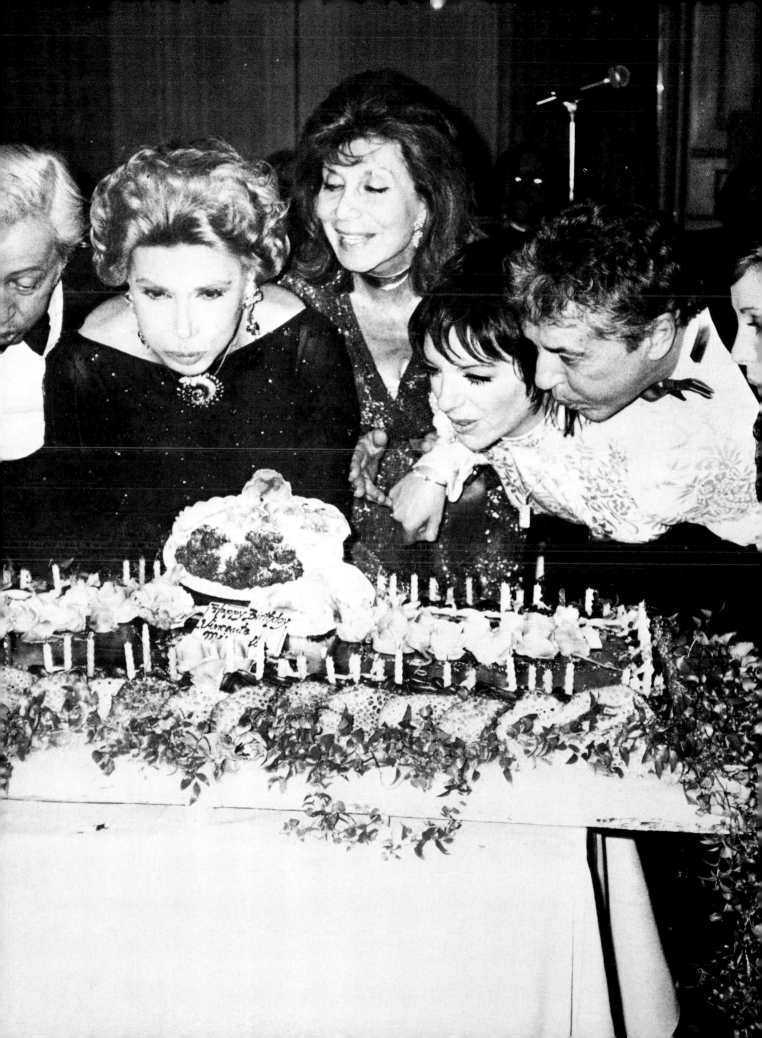

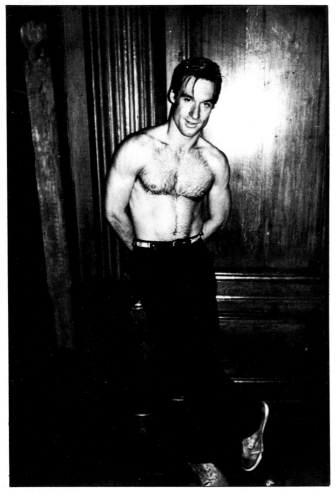

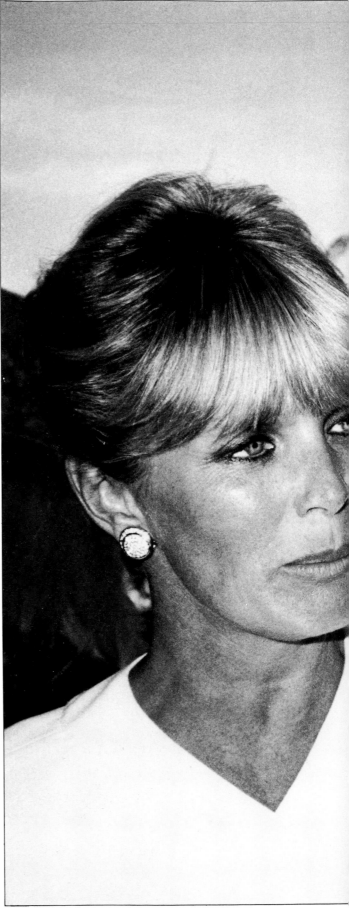

Phoebe Cates of "Lace"; Lance Loud from "An American Family"; "Dynasty" 's Linda Evans and John Forsythe.

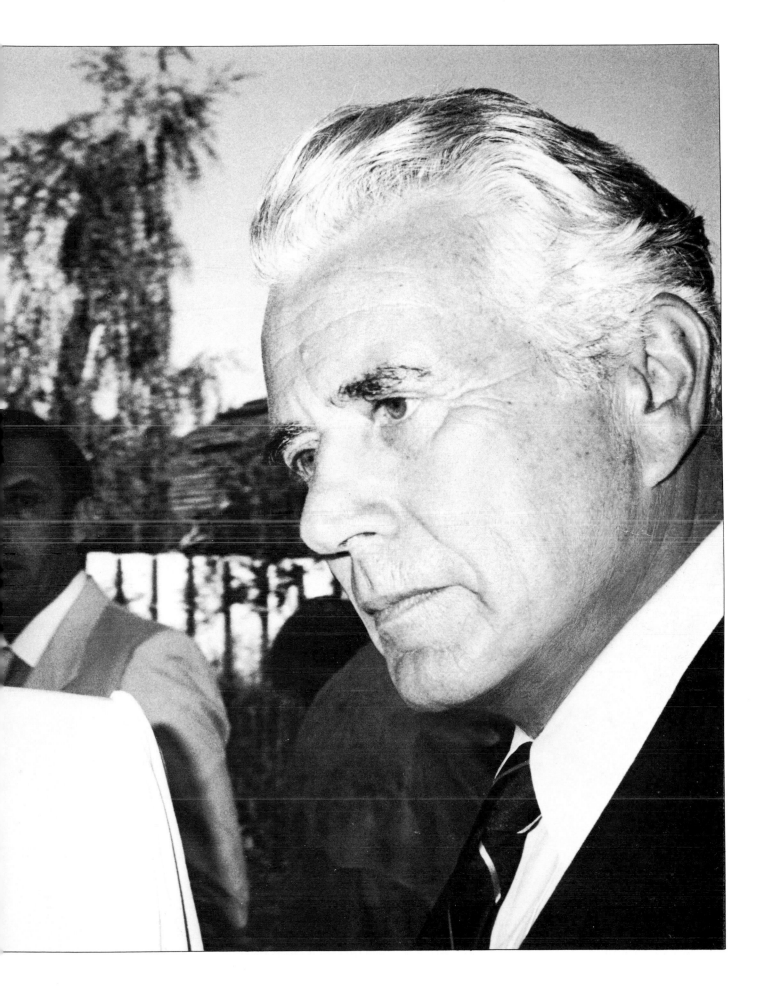

You get used to being with models and with people who live off their good looks. Then you're around all these athletes and you start thinking that they do the same thing, when they're actually out there because they're doing a good job, and when they stop doing a good job they're washed up even if they still look great.

We might think, "Steve Garvey's so good-looking, he could be a movie star," but the professionals only think, "What's his batting average for the past few months?"

Recently, there've been some people who've claimed to be celebrities who got a lot of press in New York. Two girls said they were the "Vanderbilt twins," and a man claimed to be a Rockefeller. They were terrific actors and they pulled the whole thing off (at least for a while), and they ended up with the full treatment: loans of money, credit at bars and restaurants and stores, VIP rooms, free drinks and food and entertainment and limousines—the works.

Then the truth came out, everybody got furious and the people who lost money on the deal all sued for fraud.

But I can't understand why the people who didn't lose any money got upset. If these kids were such great actors, and if they had so much aura that everybody believed it, so what?

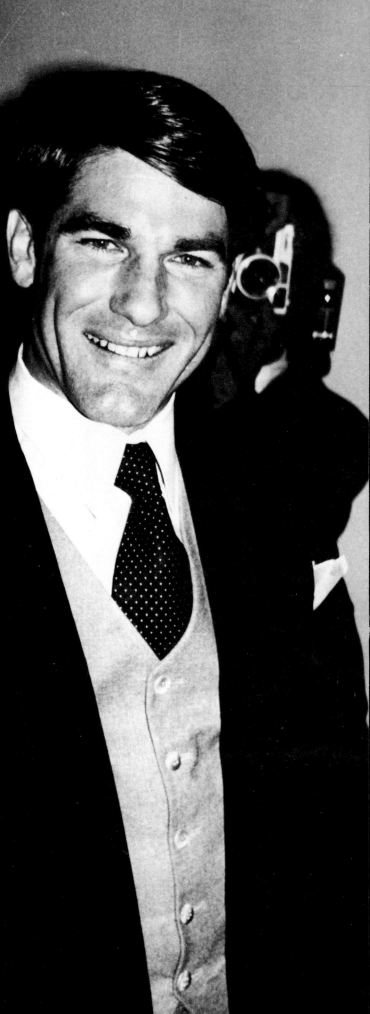

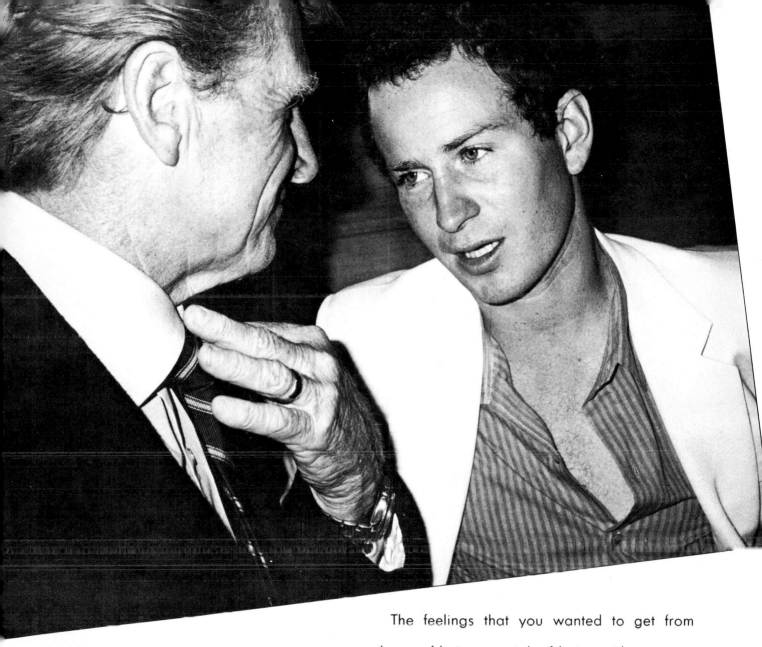

The feelings that you wanted to get from them—of being special, of being with someone who's different and better and famous—you got, as long as you believed.

Maybe these kids were even better to be around than the real celebrities would have been—maybe they were better looking or more charming or more grand. The real Vanderbilts and Rockefellers probably wouldn't have ever gone to the restaurants, the bars and the shops

Steve Garvey; Lloyd Bridges with John McEnroe; the American Olympic gymnastic champions.

these kids turned up at; they probably wouldn't be hanging around with the people these kids brought their magic to.

Except for the people who lost money, I think everyone got a good deal. People who needed some excitement got it, the kids (who wanted so much to be famous) got famous, with all the perks and their names in the papers for the fraud. Really, they were just doing what everyone in America does—selling their talent. If they had just been a little more talented, they could have gotten rich overnight.

The funny thing about getting famous is that it usually never happens to people who go after it. Even today when there are new celebrities by the minute, you still have to be famous for something, and you have to work at the something all the time. Those who spend all their time thinking about press agents and getting coverage and game show guest appearances don't spend enough time on the something, and they can't stay famous for long.

So there are people who work all the time— they can't think of anything more fun than the work they do and so they do it around the clock—and they're the ones who end up rising above everyone else and getting famous.

And the truth is that they never wanted to be famous in the first place.

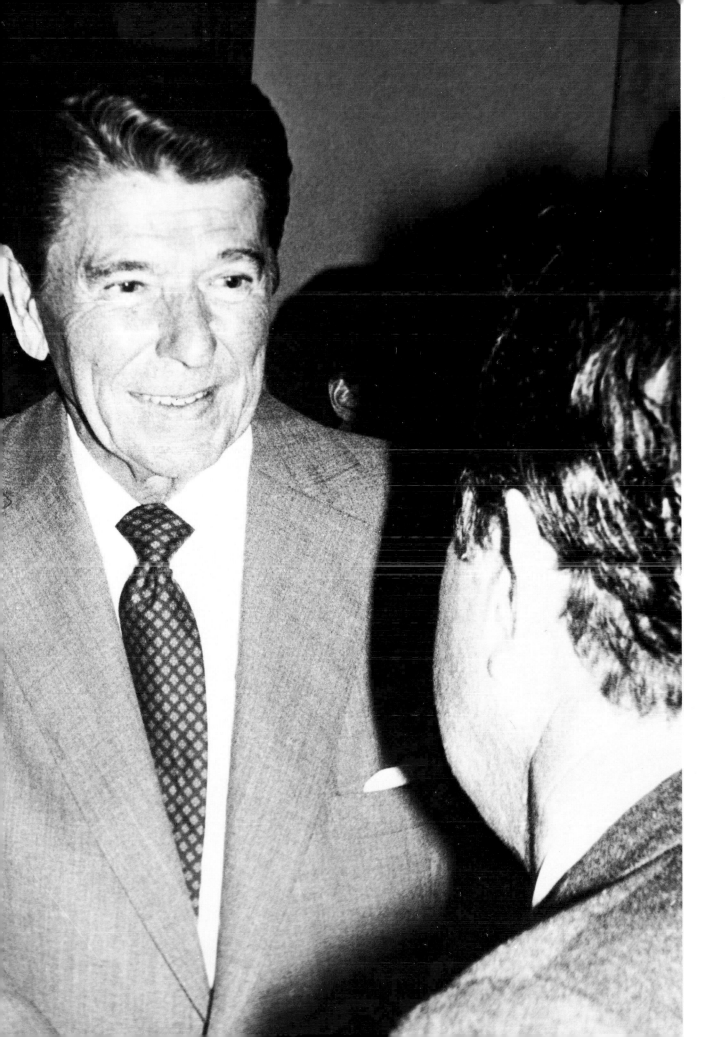

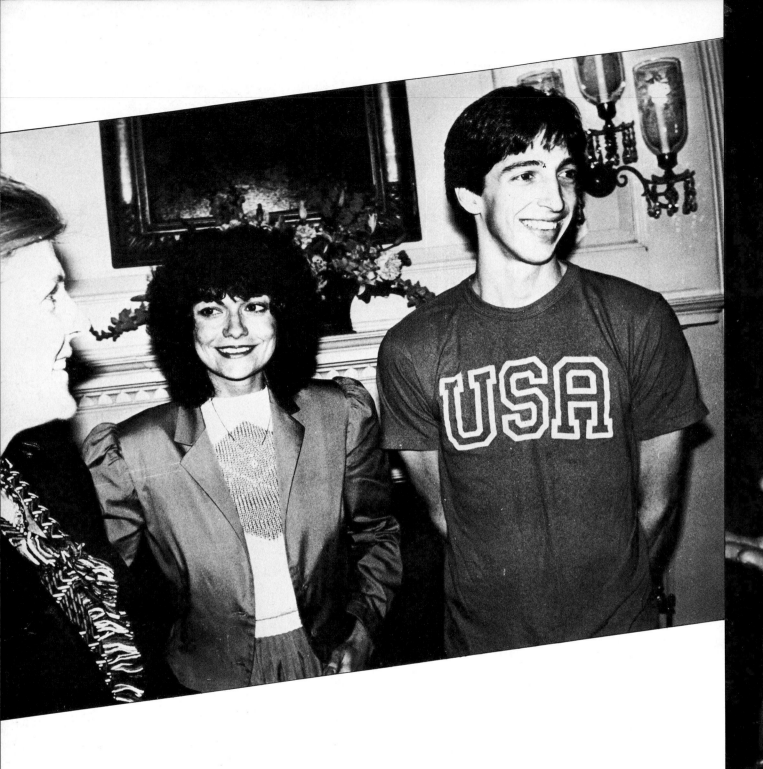

Andy Warhol: You know, I always thought they should have a lottery where they invite one family to dinner every night because it's so exciting to be here at the White House.

Nancy Reagan: There are tours, of course, Andy.

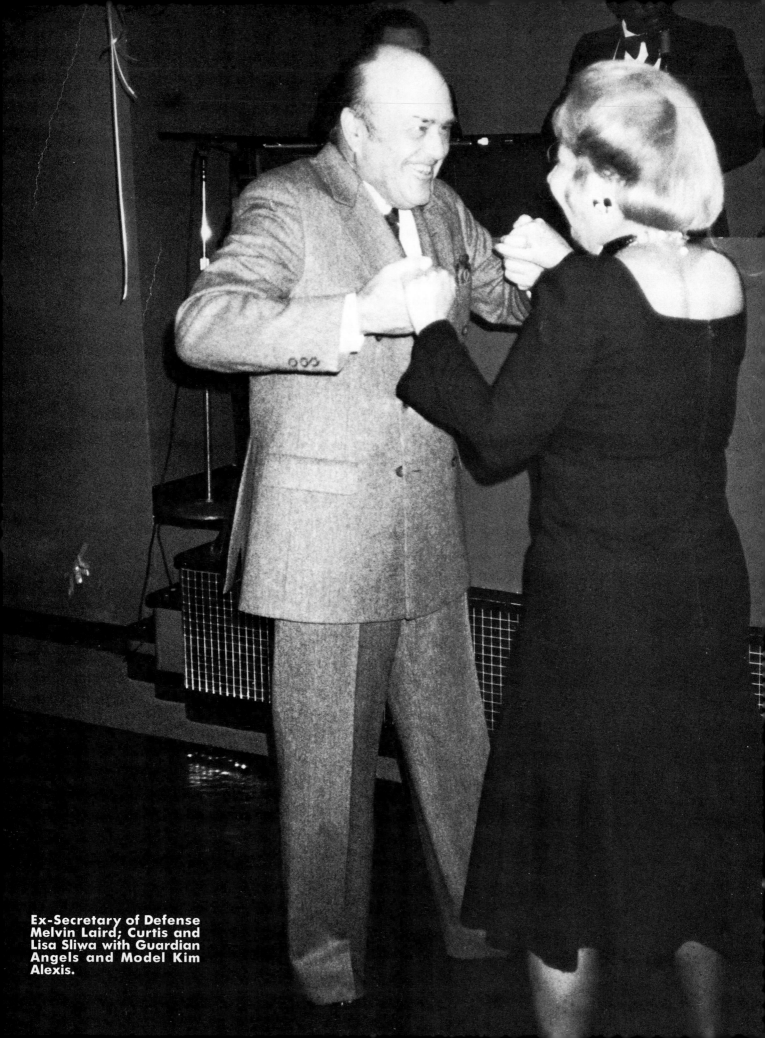

Ex-Secretary of Defense Melvin Laird; Curtis and Lisa Sliwa with Guardian Angels and Model Kim Alexis.

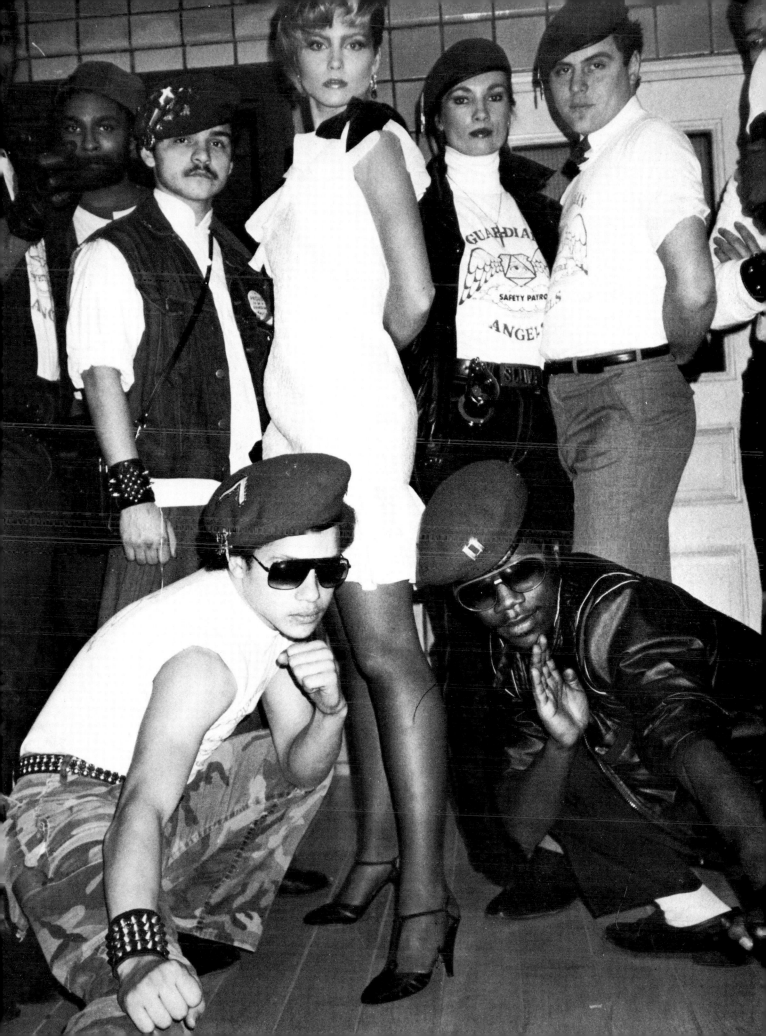

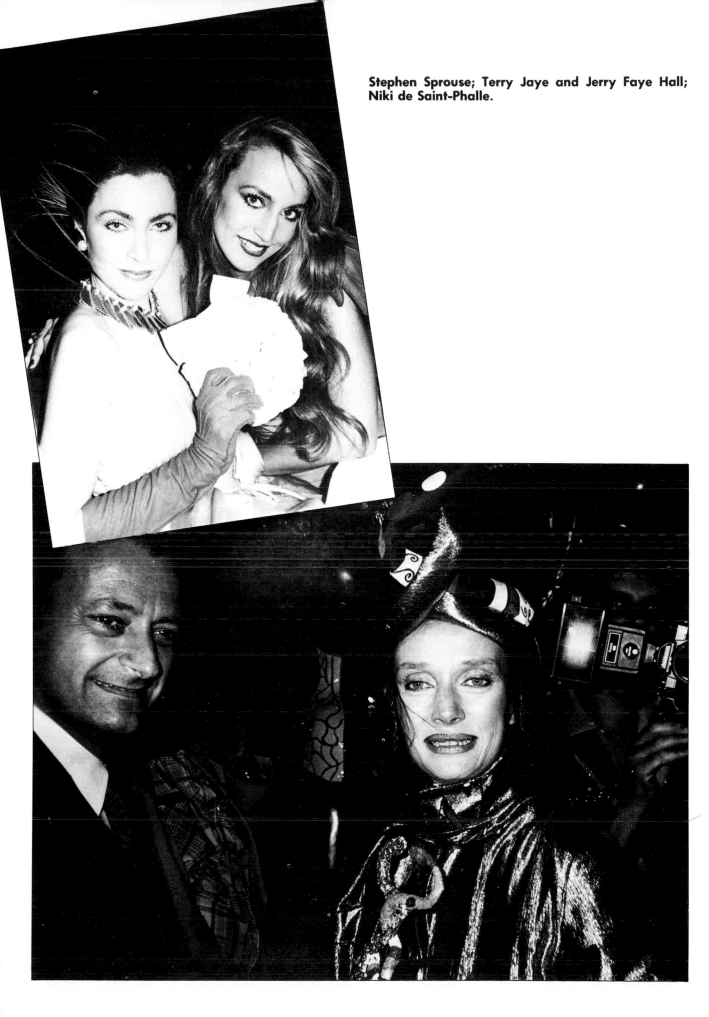

Stephen Sprouse; Terry Jaye and Jerry Faye Hall;
Niki de Saint-Phalle.

Paloma Picasso; Calvin Klein; Gloria Vanderbilt with
the late Eugenia Sheppard.

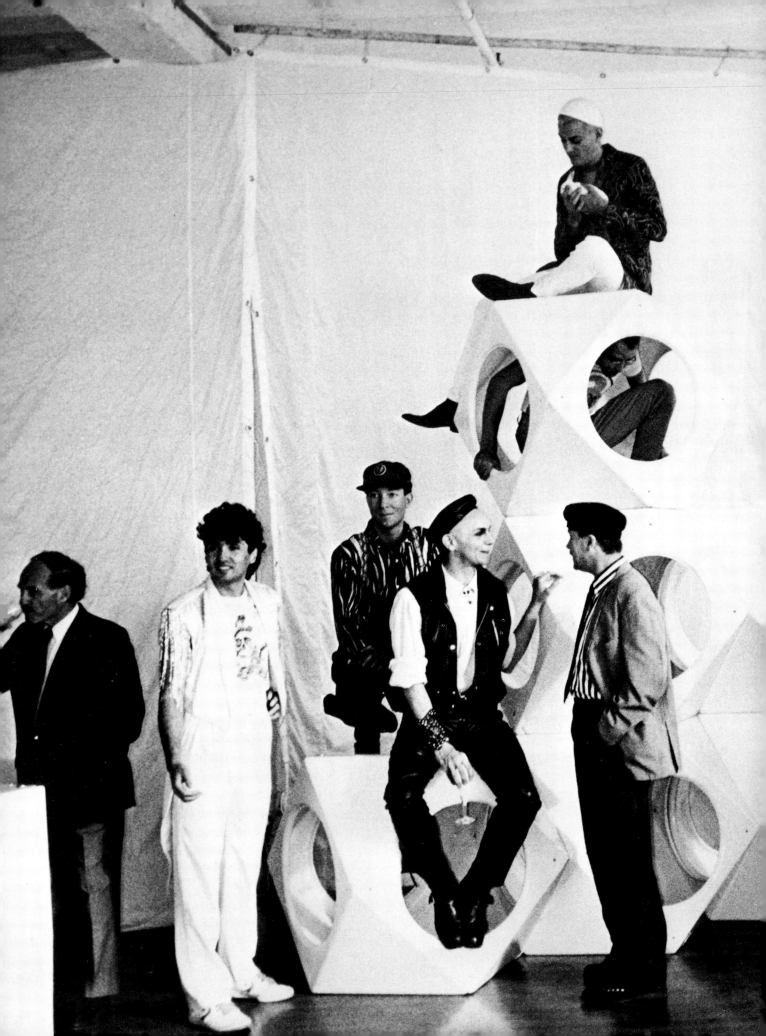

Downtown New York: Singer Fred Schneider of the B-52s, hostess Bernard/Zette, performance master John Sex, artist Keith Haring, fashion plate Benjamin Liu, designer Way Bandy, d.j. Johnny Dynell, designer Dianne Brill, socialite Kevin Boyce and producer Lester Persky.

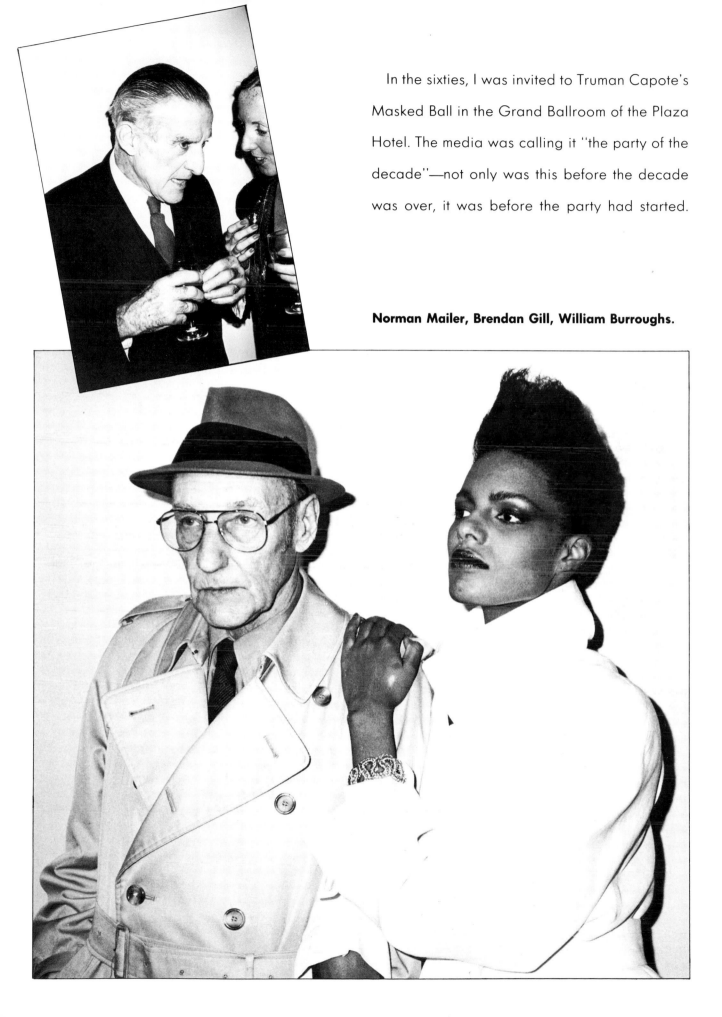

In the sixties, I was invited to Truman Capote's Masked Ball in the Grand Ballroom of the Plaza Hotel. The media was calling it "the party of the decade"—not only was this before the decade was over, it was before the party had started.

Norman Mailer, Brendan Gill, William Burroughs.

I was totally intimidated. I'd never seen such a herd of celebrities before in my life: Katharine Graham, John Kenneth Galbraith, Philip Roth, David Merrick, Oscar de la Renta, David O. Selznick, Norman Mailer, Henry Ford, Tallulah Bankhead, Rose Kennedy and, as Suzy Knickerbocker would say, "like that."

As far as I could tell, this was the densest concentration of celebs in the history of the world. As Henry Geldzahler and I stood there, gaping, I told him, "We're the only nobodies here." He agreed.

It was so strange. I thought: you get to the point in life where you've actually been invited to the party of parties—the one people all over the world were trying desperately to get invited to; the one with all these incredible dramas going on over who was invited and who wasn't—and it still doesn't guarantee that you won't feel like a complete dud! I wonder if anybody ever achieves an attitude where nothing, and nobody, can intimidate them. I thought, "Does the President of the United States ever feel out of place? Does Liz Taylor? Did Picasso? Does the Queen of England? Or do they always feel equal to anyone and anything?"

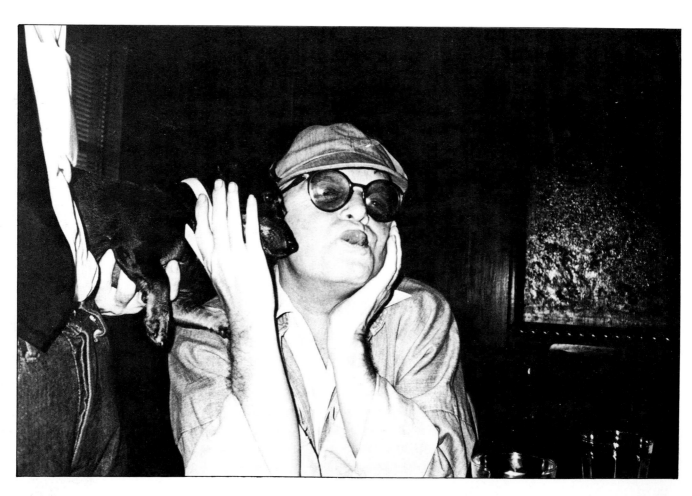

Truman Capote (the scars were from a facelift).

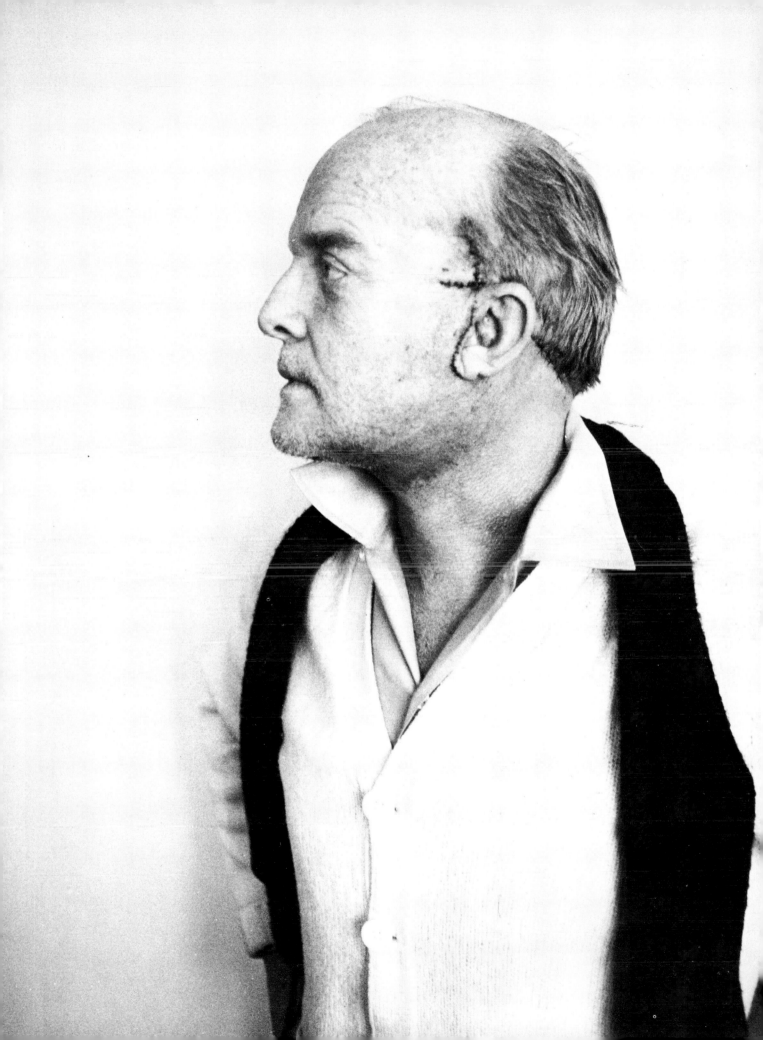

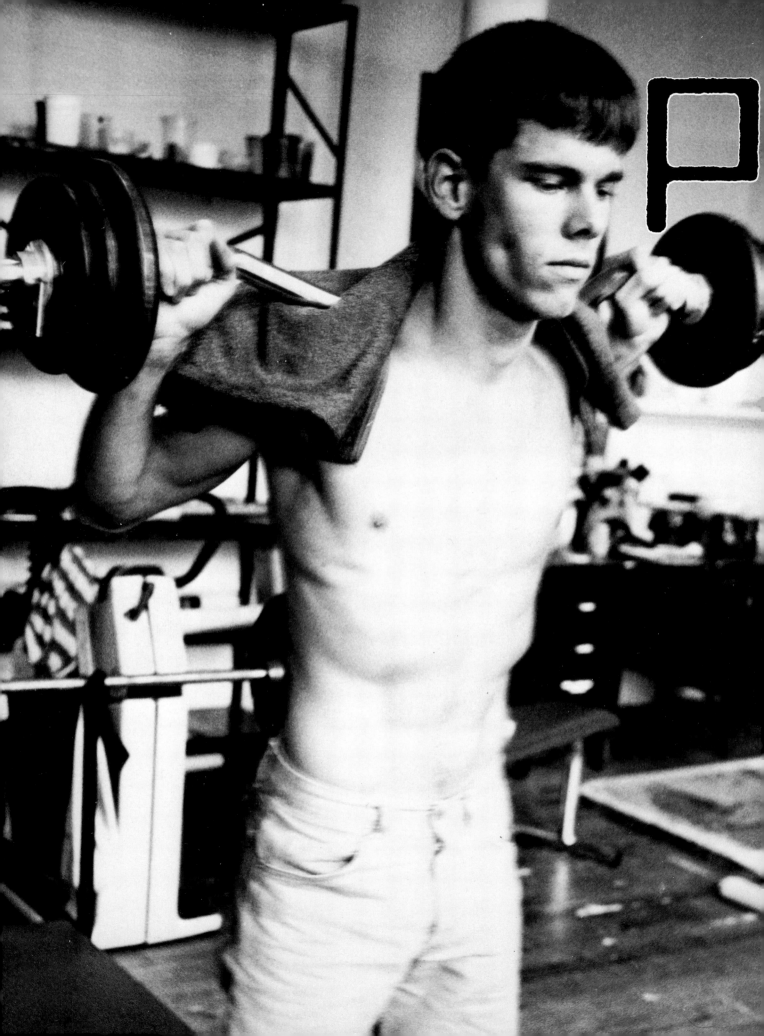

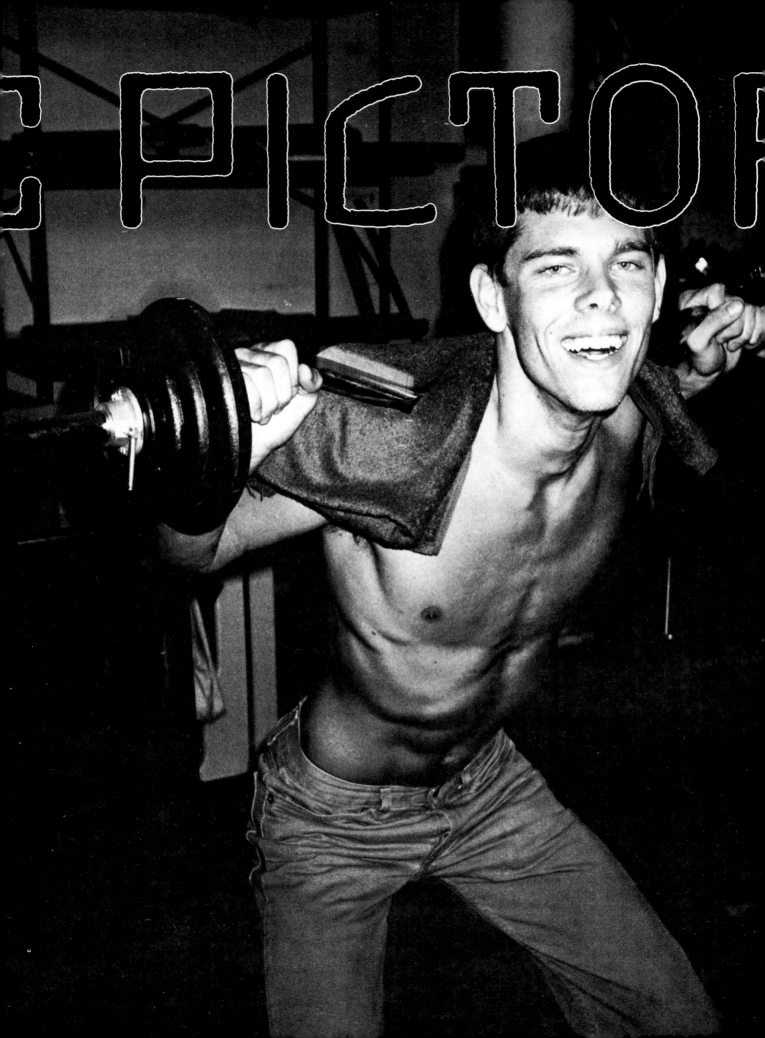

IAL

So many people have such great bodies today that the sort of lumpy, sit-around-the-house flab that used to be "normal" now looks really bad. You can't go anyplace in America without seeing boys and girls and men and women who look like they've been professional athletes their entire lives. Everybody's jogging and bike riding and working out in gyms and swimming and going cross-country skiing or doing "power" stuff like triathlons. So if you just work at your office and then have a few drinks and go home and watch TV, just like everybody used to do, you're the minority and compared with everyone else you end up looking terrible.

It's amazing what happens when someone you know really gets going with their exercising. It usually happens so slowly that you don't even notice it, but after a year or so suddenly you realize that they're completely different. Where maybe they used to be sort of dumpy, now they look terrific and they know it, and they know that you know it. So your friendship changes and if

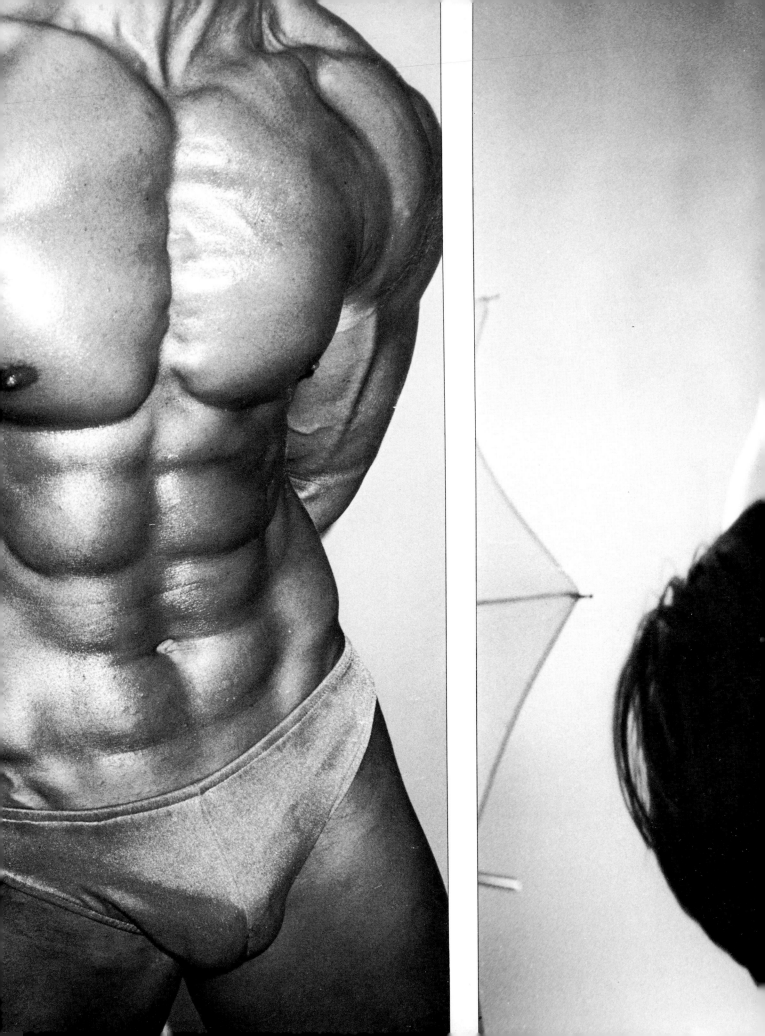

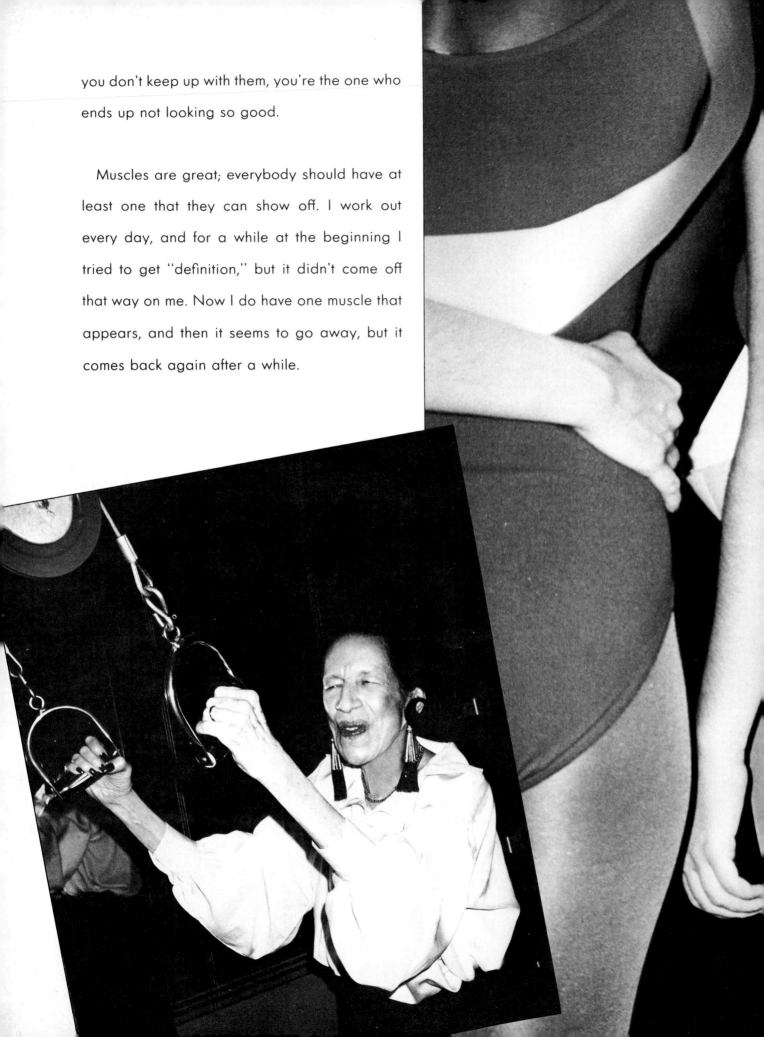

you don't keep up with them, you're the one who ends up not looking so good.

Muscles are great; everybody should have at least one that they can show off. I work out every day, and for a while at the beginning I tried to get "definition," but it didn't come off that way on me. Now I do have one muscle that appears, and then it seems to go away, but it comes back again after a while.

The men of Chippendales.

Big John Studd (6 feet 10 inches tall).

ALL-

When you first start watching professional wrestling on TV, you think you're seeing brute force without much thinking behind it. But then you watch for a while, or you go to a match and get up close, and you see all the effort the wrestlers put into getting an unusual name and outfit, all the physical work and what real gymnasts they are, and how hard they act "brute dumb" for the show they're in. It's worth watching on TV just to hear all the great names, like Hulk Hogan, Gorilla Monsoon, Brutus Beefcake, Mister Wonderful, Sgt. Slaughter and The Wild Samoans.

On the following pages:
Rowdy Roddy Piper and Cowboy Bob Orton; Junkyard Dog vs. Blackjack Mulligan; Andre the Giant vs. Ken Patera; Rowdy Roddy, The Tonga Kid, "Superfly" Snuka, Cowboy Bob.

STARS

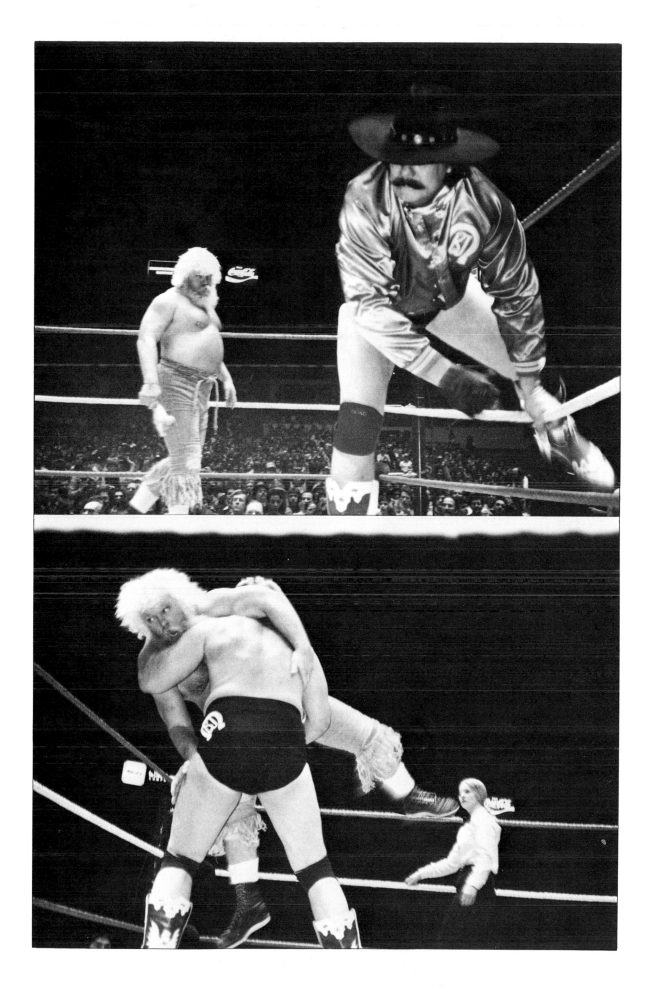

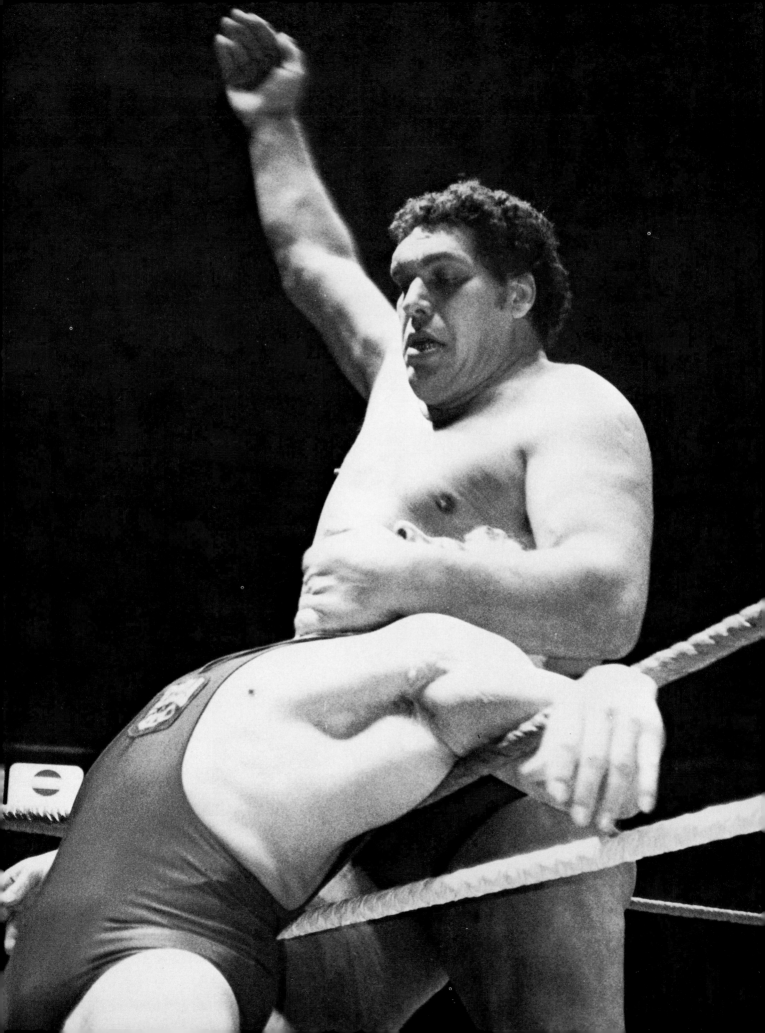

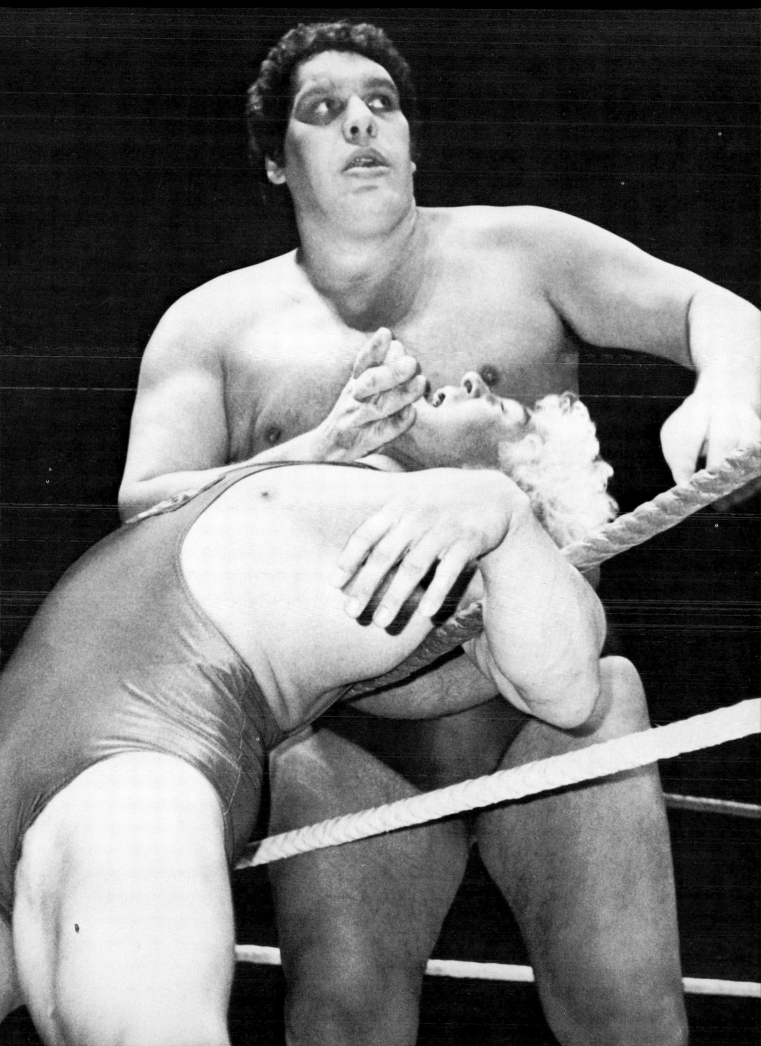

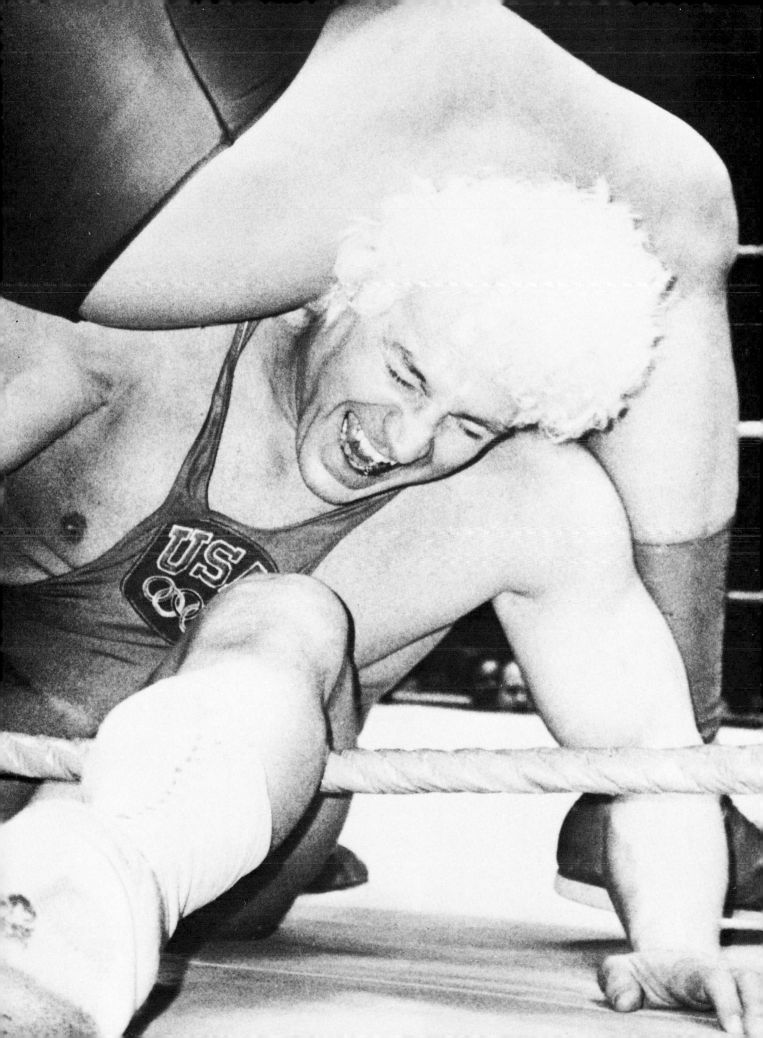

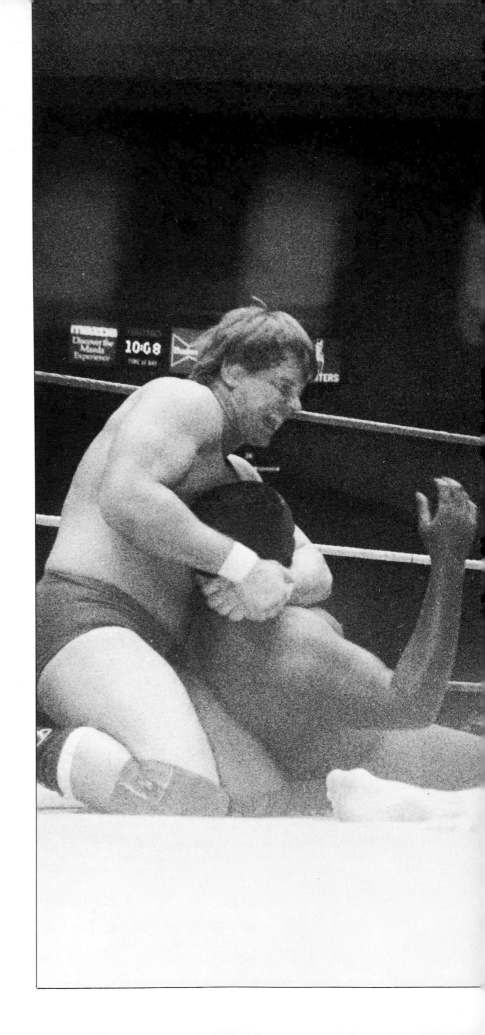

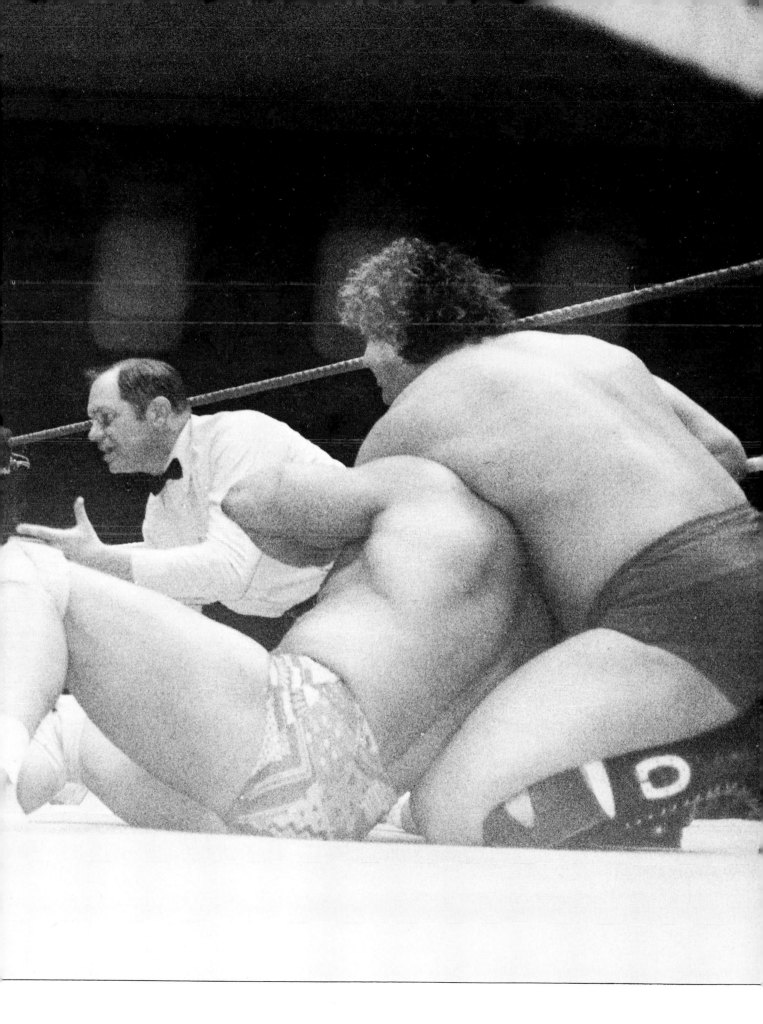

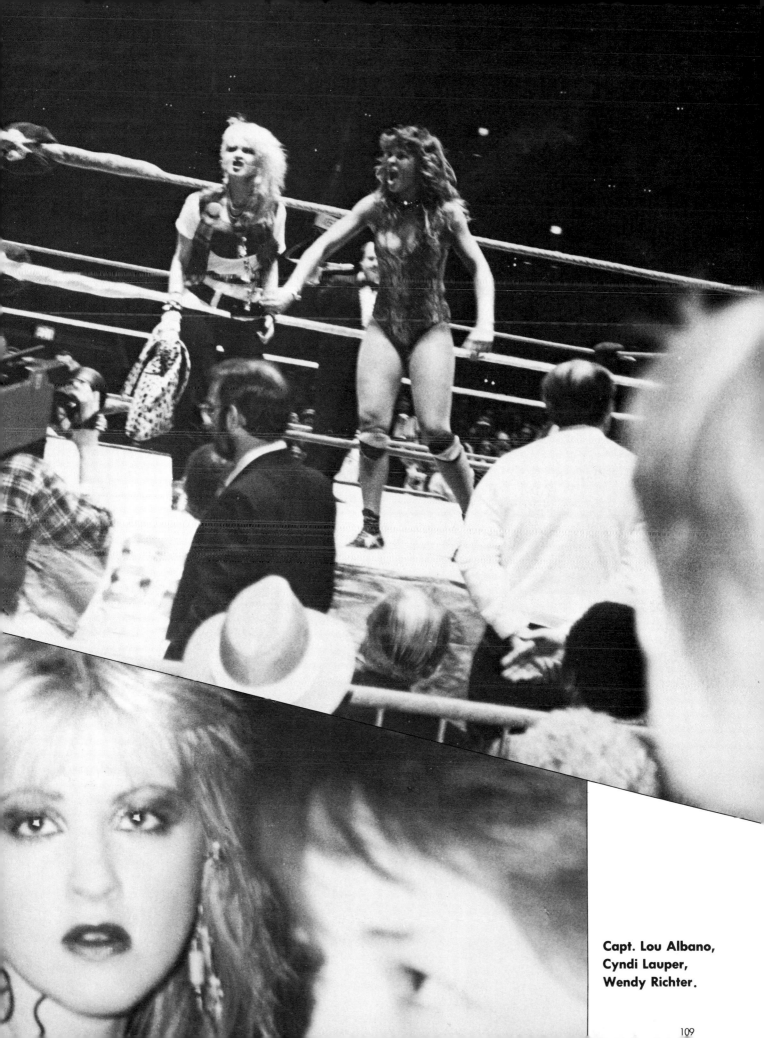

**Capt. Lou Albano,
Cyndi Lauper,
Wendy Richter.**

For my second show at the Ferus Gallery in Los Angeles—the Liz-Elvis show (1963)—I rode cross-country from New York in a station wagon with Wynn Chamberlain, Taylor Mead and Gerard Malanga. It was a beautiful time to be driving across America; I'd never been west of Pennsylvania on the ground before. The girls were still wearing cashmere sweaters with little round necklines and tight, straight fifties skirts. There was a time gap in those days of up to three years between when new fashions showed

GRAPHI

up in New York City and when they filtered out to the rest of America. By the end of the sixties, though, with media life-style Pop coverage so fast and furious, this gap had almost closed.

The farther west we drove, the more Pop everything looked on the highways. Suddenly we all felt like insiders because even though Pop was everywhere—that was the thing about it, most people still took it for granted whereas we were dazzled by it—to us, it was the new Art. Once you "got" Pop, you could never see a sign the same way again. And once you thought Pop, you could never see America the same way again.

The moment you label something you take a step—I mean, you can never go back again to seeing it unlabeled. We were seeing the future and we knew it for sure. I saw people walking around in it without knowing it, because they were still thinking in the past, in the references of the past. But all you had to do was *know* you were in the future, and that's what put you there.

The mystery was gone, but the amazement was just starting.

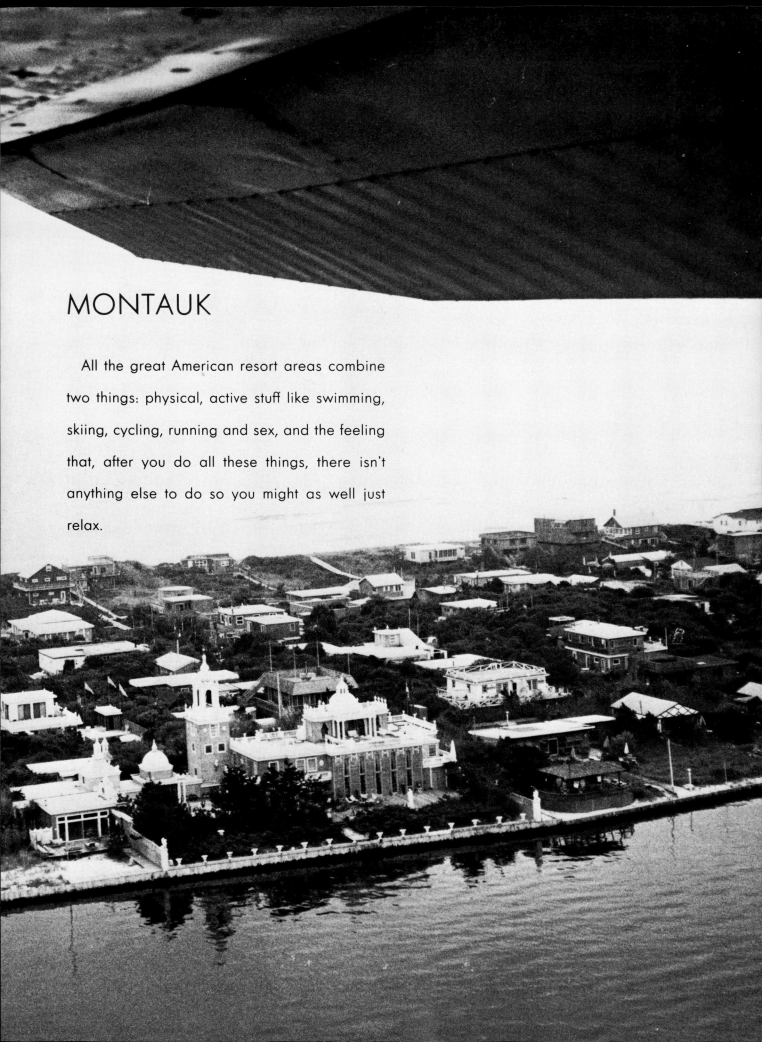

MONTAUK

All the great American resort areas combine
two things: physical, active stuff like swimming,
skiing, cycling, running and sex, and the feeling
that, after you do all these things, there isn't
anything else to do so you might as well just
relax.

When you're young and good-looking and you've got a great body, you like to go to the beach and show it all off. And it's easy for you to make fun of everybody there who isn't so good-looking or in such good shape.

But I think it takes a lot of courage to be really fat, or have very white skin that never tans, or be really old and go to the beach. You wear your bathing suit and show yourself off anyway, and you have the attitude that this is what I am, and it may not be so great but it's me, and I really don't care what you think about it.

That's a great American kind of courage.

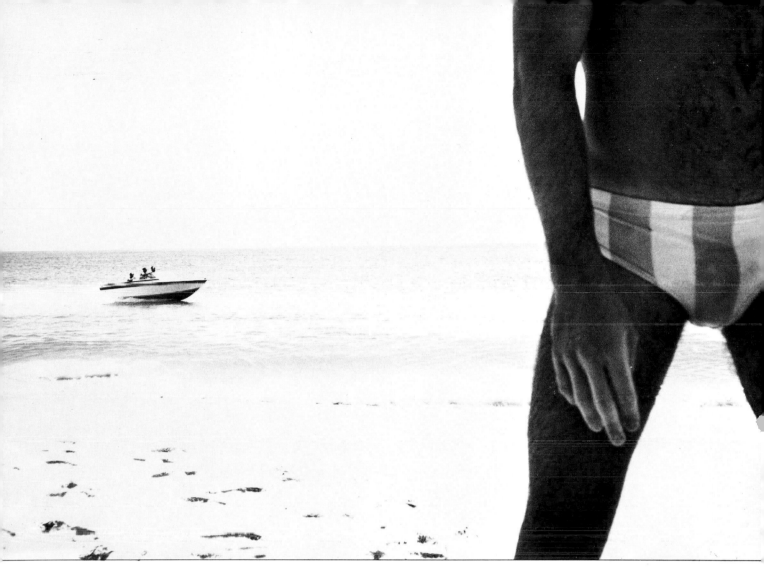

NEWPORT

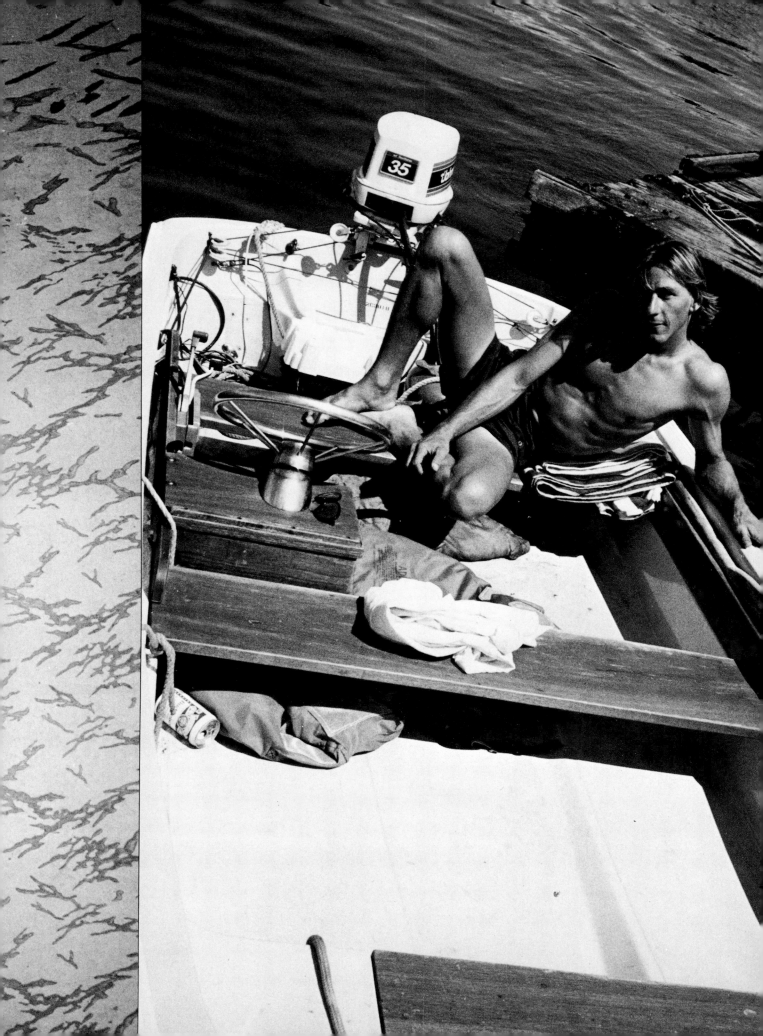

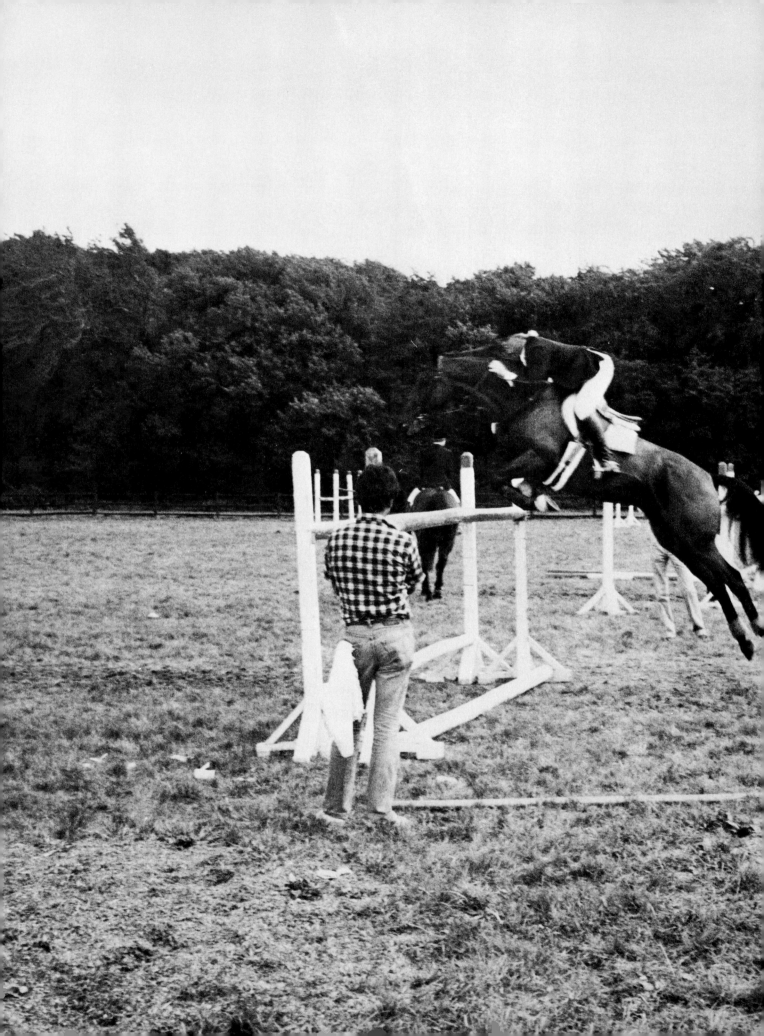

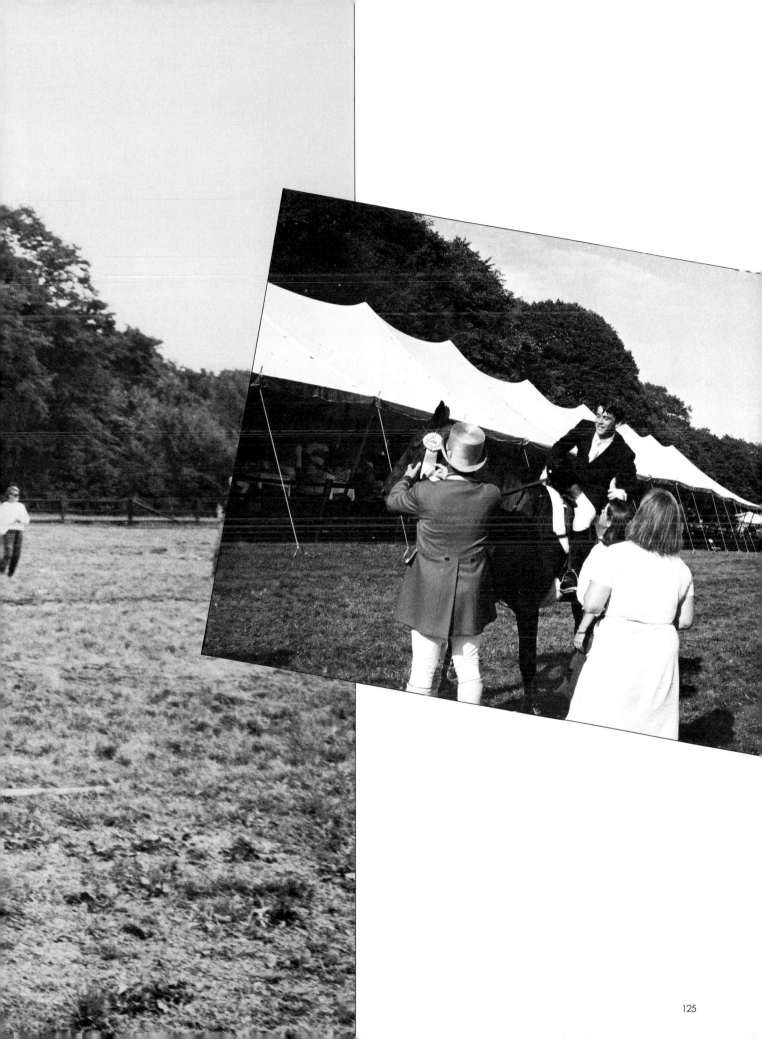

LENOX

When I got shot, two bullets went through my stomach, liver, spleen, esophagus, left lung and right lung. The doctors and everyone else, including me, was sure I was going to die, so we all got ready, and then I didn't do it. But I always wished I had died, and I still wish that, because I could have gotten the whole thing over with.

Dying is the most embarrassing thing that can ever happen to you, because someone's got to take care of all your details. You've died and someone's got to take care of the body, make the funeral arrangements, pick out the casket and the service and the cemetery and the clothes for you to wear and get someone to style you and do the makeup. You'd like to help them, and most of all you'd like to do the whole thing yourself, but you're dead so you can't.

Here you've spent your whole life trying to make enough money to take care of yourself so you won't bother anybody else with your problems, and then you wind up dumping the biggest problem ever in somebody else's lap anyway. It's a shame.

I never understood why when you died, you didn't just vanish, and everything could just keep going the way it was only you just wouldn't be there.

I always thought I'd like my own tombstone to be blank. No epitaph, and no name.

Well, actually, I'd like it to say "figment."

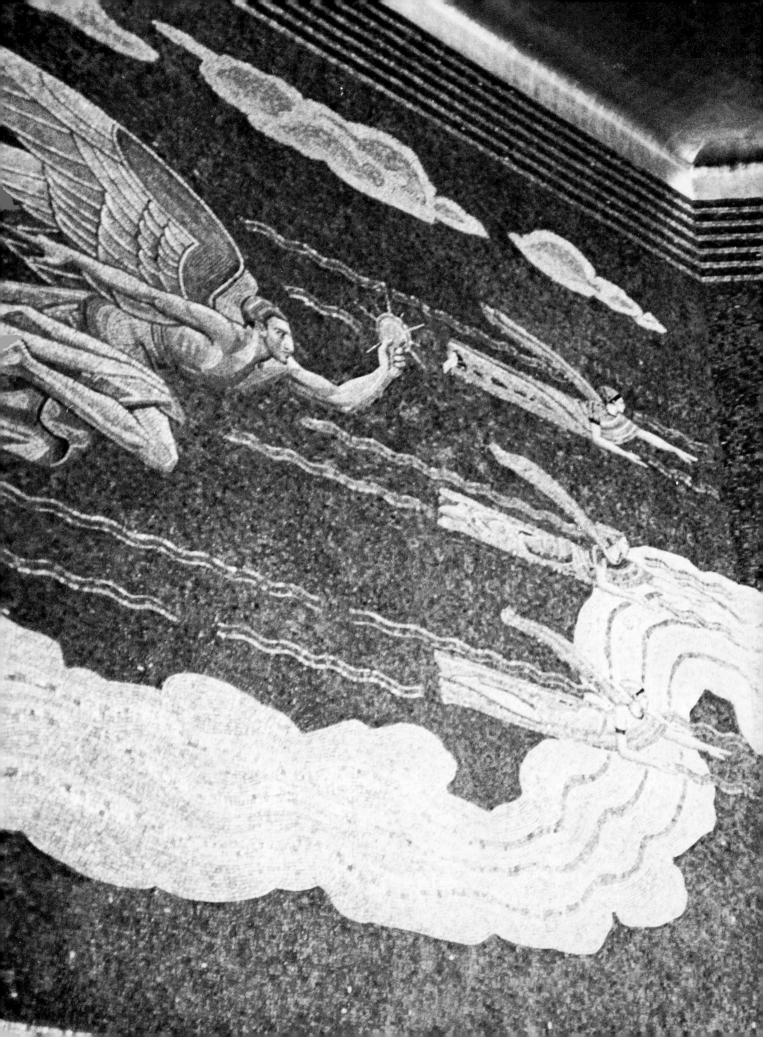

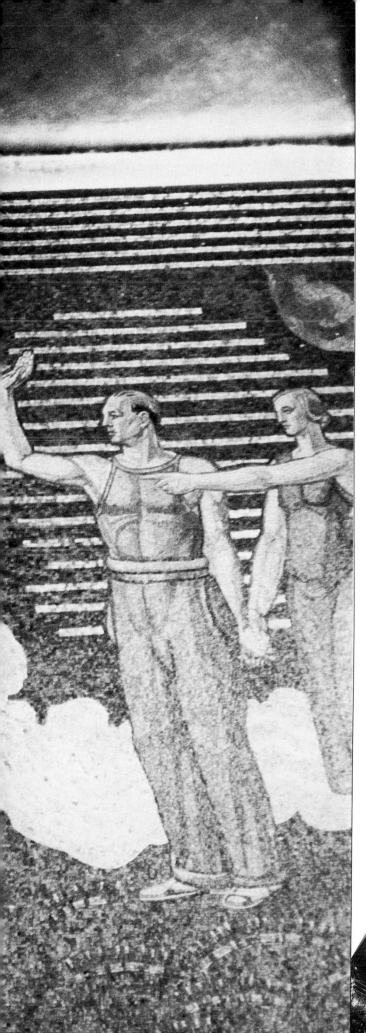

NEW YORK CITY

During the '84 political campaigns I heard a slogan that was really good—"We can't ALL be computer engineers"—but after the election I never heard it again. And the other day I was walking through Rockefeller Center with the big murals on the walls and I was thinking about it.

I love that kind of WPA art; the big, tough peasant look. The big strong men with the work-muscles and the sweat, doing their jobs and building America. And then I was thinking, what would the worker murals of today be like?

They say we're a service economy now—that there are more people selling us hamburgers than making us steel and things. So would the huge wall murals of today be of the people sit-

ting at computer terminals and the people at Burger King handing you your fries? Is there any way to make that look heroic?

I don't think there's any place in the world like New York City as far as street life goes. Here you can see every class, every race, every sex and every kind of fashion bumping up against each other. Everyone gets to mix and mingle and you can never guess what combinations you're going to see next.

The movies and TV like to separate everybody when they show New York, so you'll see a whole New York movie made up of rich people getting in and out of limousines and spending their lives going to museums and eating lunches at stuffy restaurants. Or it's white and clean and middle-class, with these helpful upstairs neighbors who are always sweet and eccentric and cooking these "Old World" meals. Or it's a New York where criminals run the streets and every alley is filled with gangsters and everyone carries a gun or a switchblade and there's a murder every three minutes. Or maybe it's an "art" movie where the boys wear makeup and the girls have crewcuts and nobody has a personality like anyone you've ever met and everyone talks in this strange philosophic way and they're all sleeping with each other for no reason.

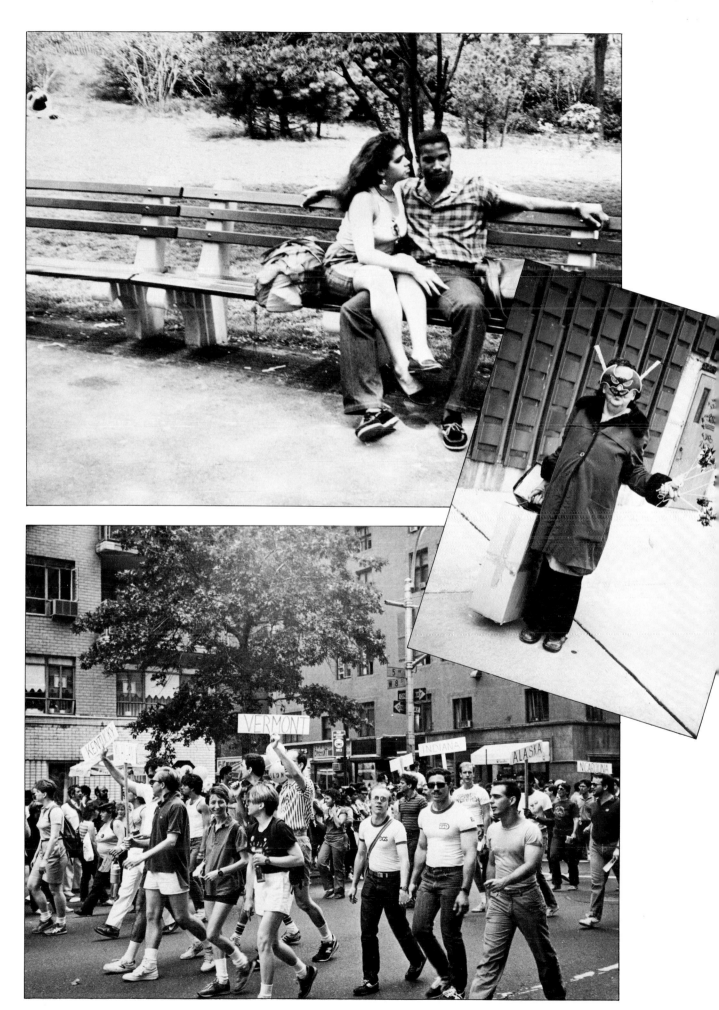

But the great thing is that all of this is true and in New York it's all happening at the same time.

When I'm walking in the streets of New York one thing I think is really funny is to remember its history and how things rise and fall, and then rise again. Today, the Upper East Side is the most exclusive and expensive neighborhood to live in, but it used to be where all the poor Irish immigrants were forced to go, with the noise from the elevated train every fifteen minutes and industrial dirt everywhere. The townhouses and

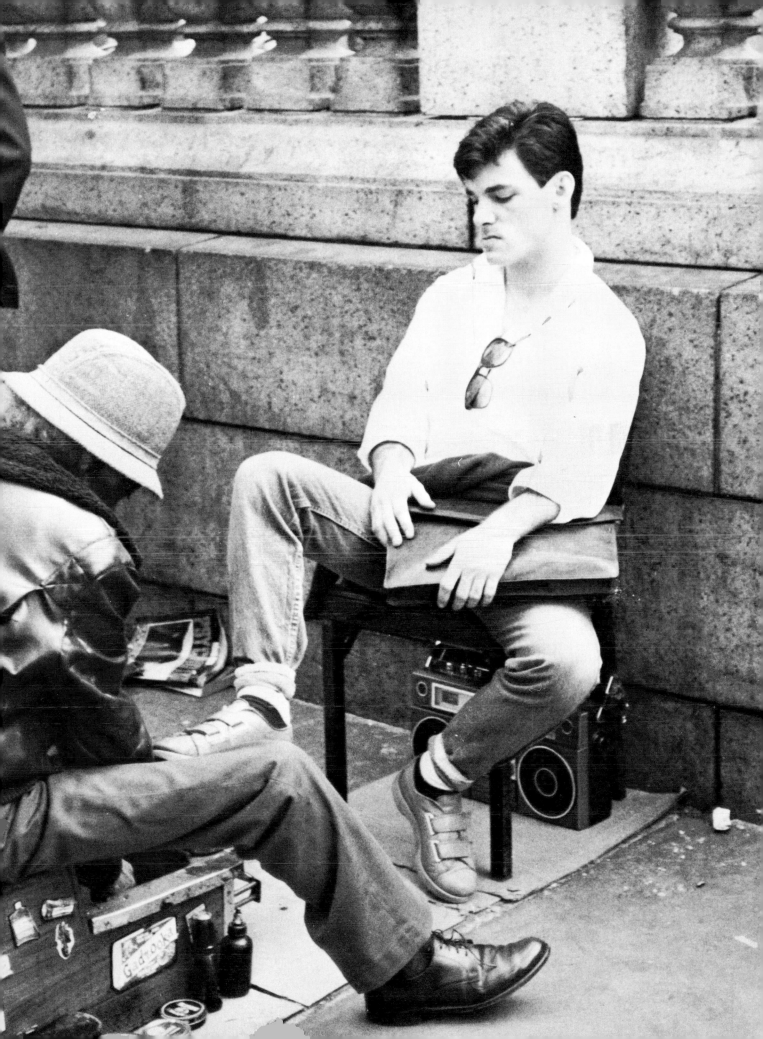

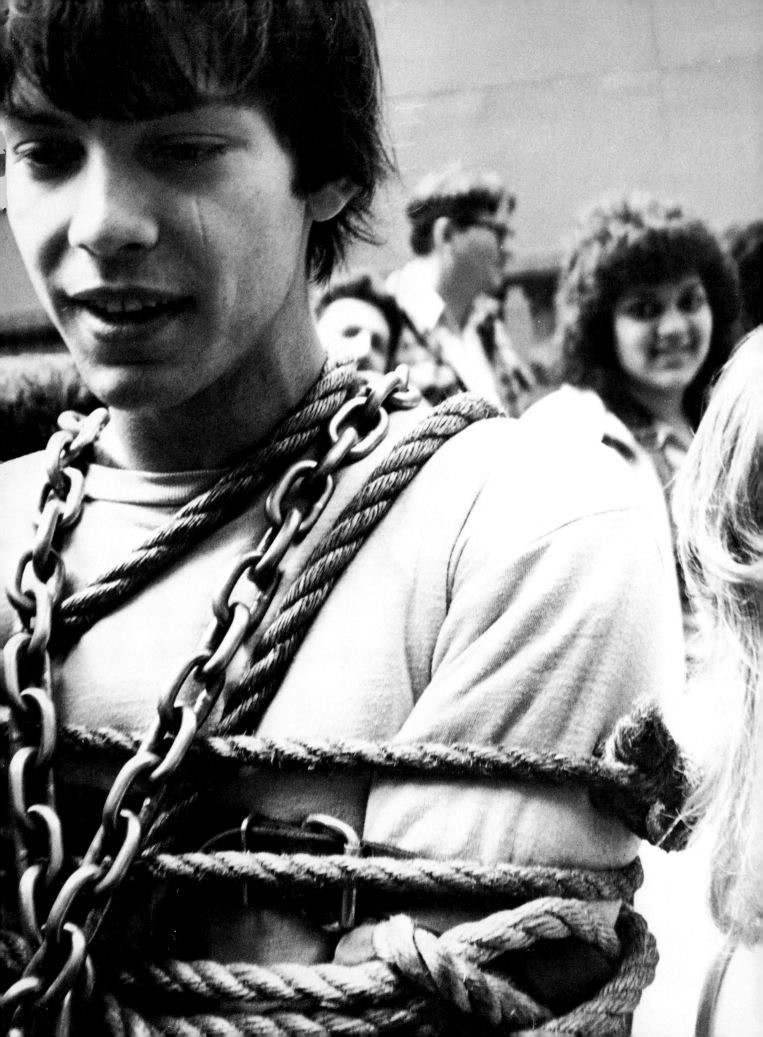

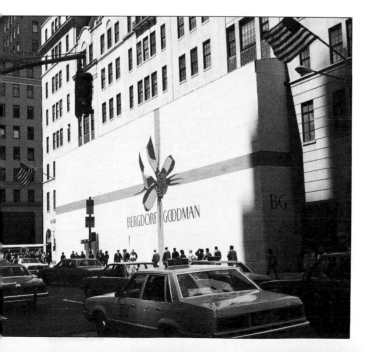

New York University buildings surrounding Washington Square Park are some of the nicest in the city, yet this park is where they used to hang criminals and there are over 10,000 people buried there and the hanging tree is still growing. And lots of the downtown Wall Street area used to not even exist, it's landfill dredged up from the sea.

So when people are really haughty about where they live in Manhattan, and many of them are, you can think about the past and how they're living on top of something that used to be pretty awful. Such as people who like to think that Manhattan was really beautiful before cars came along, that the air was crystal clear and the water around the island was clean, that there was never any pollution. But what really happened was that all the horses created terrible manure problems, with the air polluted by manure dust, and everybody dumped their sewerage right into the water and the stench was incredible.

For a pretty long time New York was really on the skids because of the financial problems and lots of people were leaving because the services were deteriorating and strikes were on every other day and it looked like there would be riots in the streets and the city would have to declare bankruptcy. This was when the *Daily News* had

its famous headline, "Ford to City: Drop Dead," and it was also when it was fashionable to live out in the country or in a small town, or even in Europe. So lots of New Yorkers, especially lots of the rich, left and the ones who stayed behind could get these incredible townhouses and co-ops and lofts for practically nothing. Everybody was leaving and nobody was buying so the few who were had their pick of just about anything.

And now everyone's tired of living in the country and having to worry about terrorists and economic problems in Europe, and New York is looking good, so they're all moving back. And foreigners are seeing all those people coming back and buying real estate and pushing the prices up, so they're buying too, because of American financial security, or just as an investment. So the prices of any place to live is skyrocketing, and all the people who stayed behind when everyone was leaving are finding the values of their homes climbing to a point where they think they're unbelievably rich. But since every other place that's just as nice to live in is going up just as much, you can't do anything about it unless you want to leave town and live someplace cheaper, which is getting harder and harder to find in American cities.

So the young kids just moving to New York to find their fortune are instead finding that they

have to live in these incredible neighborhoods which look really dangerous because they don't have the money to pay the rent and live in a really good part of town. But when they look closely they find that the places they usually move to are filled with other kids just like them and maybe it's not so bad.

I don't know if I could take paying $1000 a month to live in a slum just because I wanted so much to live in Manhattan. You see the people paying that are really angry about it, and you see the people who've lived there a long time are angry because all these strangers are moving into their neighborhoods. And the landlords are angry that they can't raise the really long-time tenants' rent because of the rent control, so they say they have to charge all the newcomers these unbelievable prices to make up for it or else they'd go bankrupt, and even with these prices they're going bankrupt anyway. So you have a new kid living in a tiny apartment that's $900 a month, and the woman who's been there for a really long time and lives upstairs in the exact same apartment for $61 a month. And everyone thinks this is pretty unfair, except that you know if the market were "free" both of them would be paying the $900.

Stores don't get rent control, and the leases are something I can't understand. Some tiny

store in a good part of town goes for $5000 a month. Which means you have to sell $10,000 or so a month just to pay the rent, not to mention the salaries and the heat and the warehousing and everything else. They say that the only places who can do this are the ones that have either incredibly expensive things to sell or ones that pull in hordes of people. But even if you're selling ice cream cones, you'd have to sell one every minute eight hours a day every day, just to pay the rent.

So maybe in the future, the only stores in New York will be selling fur coats. Or very expensive candy.

When reporters asked the Pope what he liked best about New York, he replied, *"Tutti buoni"*—everything is good.

That's my philosophy exactly.

WASHINGTON, D.C.

America always begins with moods.

You have a certain feeling, and maybe it's the wrong mood for the movie you're going to, so you end up hating it while everybody else thought it was great. One woman I know was in a mood where she thought having a baby would be the most wonderful thing in the world, and finally when she did have one that mood was so enormous the real baby just couldn't match it, and she ended up being depressed for the first year or so and I hope it didn't hurt the baby mentally, but I'm sure it did.

If lots of people are in a certain mood, maybe they won't like a politician and the mood makes them vote him right out of office. If you're a Senator, or the President, you have a mood, and that mood is what decides what you say at any moment, or even how you set up policy and run America.

But the trouble with moods is that they're always changing, sometimes really fast. And when that happens, the movies change, the babies change, the votes change, the decisions change, and America flip-flops onto something totally new.

This makes all the other countries in the world not know what to think—one year we're yelling

The Watergate Hotel.

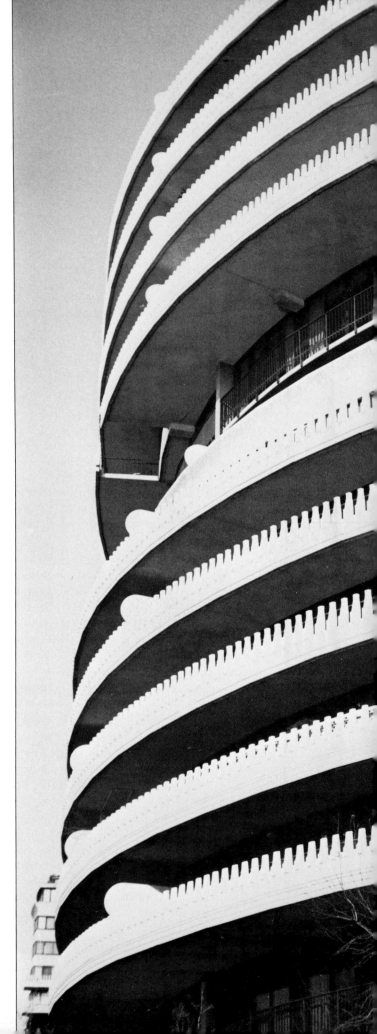

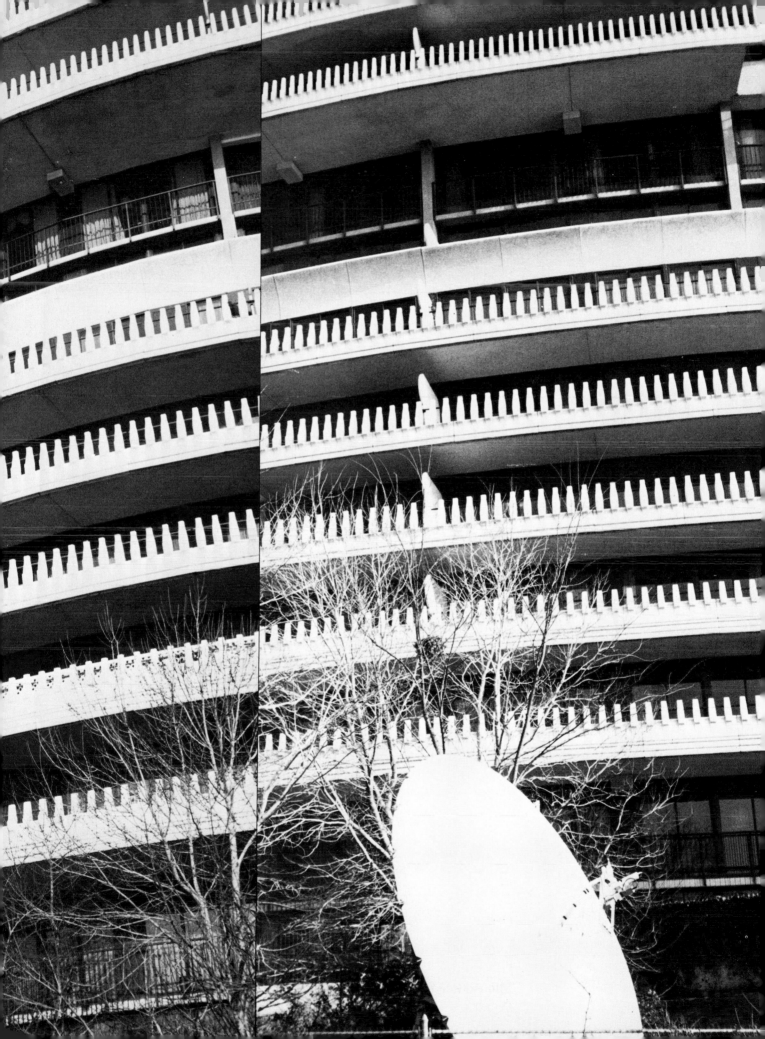

about human rights, and the next we're mining some foreign country's harbors. We're moody, and the moods swing, and we'll change our minds completely about everything. So you're always making your values, your rules and your laws based on your moods, and everything could be turned around just like that, and it's pretty unstable.

That's why the American government and the American media are so great. The President, the newsmagazines, television—they only want to capture America's mood at the moment, reflect it back, and tell anyone who's not in the same mood to get over it and start feeling American like everyone else. So if following your own moods makes you feel like everything's just up in the air, you can listen to the media and the President and just go along with whatever they say. You can talk yourself into their moods, what they think the rest of the country is thinking. Then instead of making major changes every minute, you'll be in tune with the rest of the country and make them every six months . . . and every four years.

I've always thought politicians and actors really summed up the American way. They can look at the various pieces of themselves, and they can pick out one piece and say, "Now I'm only going to be this one thing." And the piece

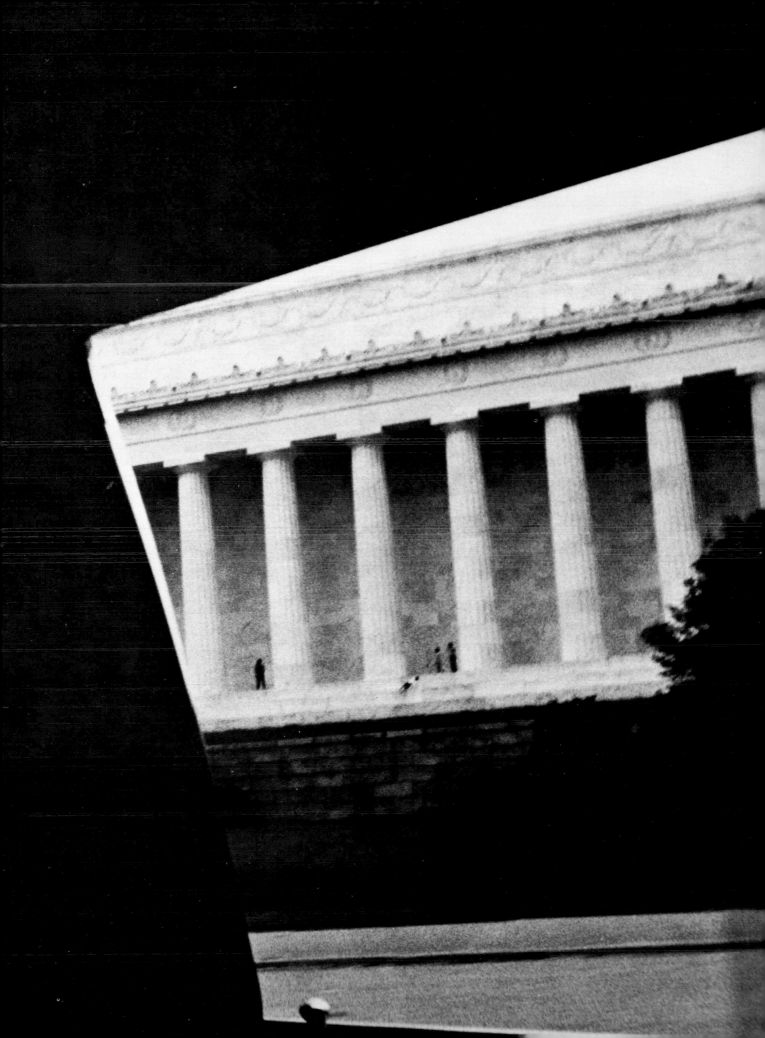

may be smaller and less interesting than the whole personality, but it's the piece that everyone wants to see.

Politicians and actors can change their personalities like chameleons, and the rest of us do it every day. Say you're on the phone, and first you talk to your boss, then your lover, and then the American Express bill collector: you take the piece of yourself that each wants, give it to them, and become a whole new person with every call. You're just like a politician except they've really practiced and they're perfect at it. They can walk into an embassy or before the news cameras and act their way into *anything*.

So I'm always wondering: do politicians ever go too far in this? Do they ever wonder: where's the *real* me?

Practically every social event you go to in Washington is formal. Even if a party is for 6:00 right after work, everyone will be dressed in tuxedos and evening gowns. It must be the only place in the U.S. where people keep formal wear hanging in their office closets for all the functions they have to attend.

With the formality, you start thinking that Washington is a very serious place. And as soon as you're swept up in the importance, in the tuxedos and the marble and the giant lawns everywhere, you'll see a tourist tram go by filled

The White House.

with people in funny T-shirts and short pants, and you get brought back down with a thud. Washington has so many tourists and all these tourist things everywhere—snack stands, uniformed guides, tour booklets, all the souvenirs you could ever imagine—it's almost like an amusement park. And you can see how this feeling starts to creep into the people who are there seeing the sights.

But then something happens. You'll watch a tourist in Washington, and they're dead tired from running around in the heat, sweating like crazy because the humidity's so bad, the kids are whining and everyone's just about had enough. Then all of a sudden they see something great—like the Declaration of Independence, or Lincoln's statue, or the Vietnam memorial with the names of everyone who died there. And you can really see this glow coming over their faces. They had thought they were just in another kind of Disney World, and they had the snacks and bought the souvenirs and rushed around to fit everything into the time they've got, but then they run up against one of the big, great, incredible American things that are everywhere in Washington, and their mind completely turns around and they realize their country's greatness and how proud they are to live there.

And it's magic.

156

KENTUCKY

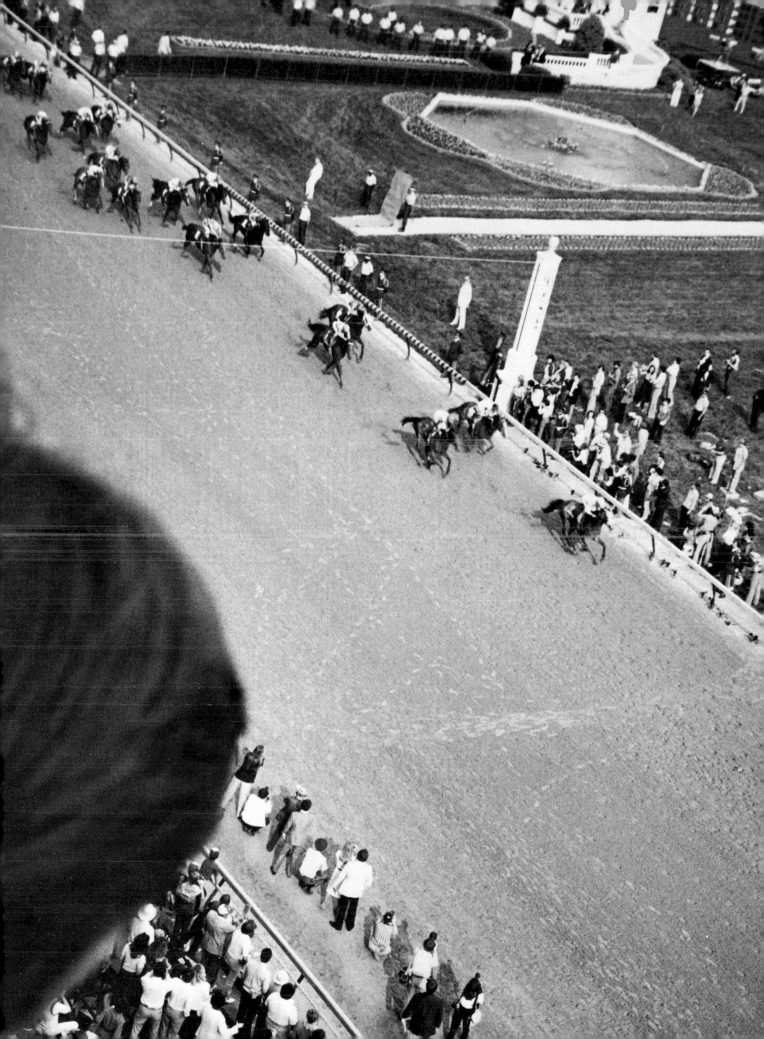

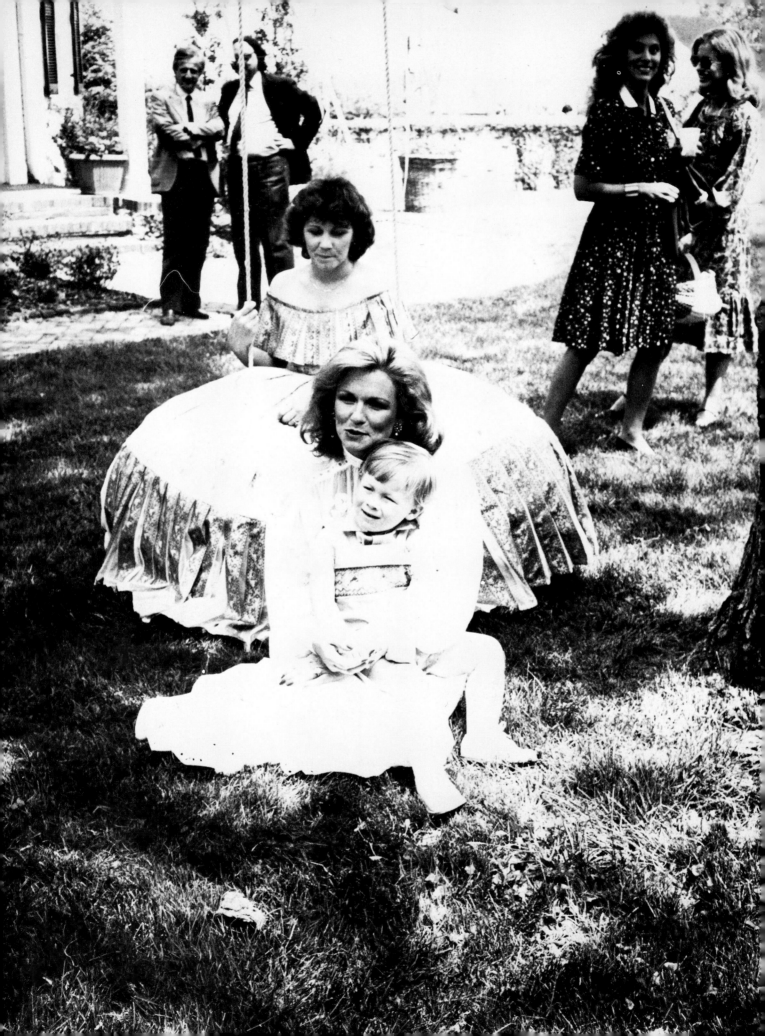

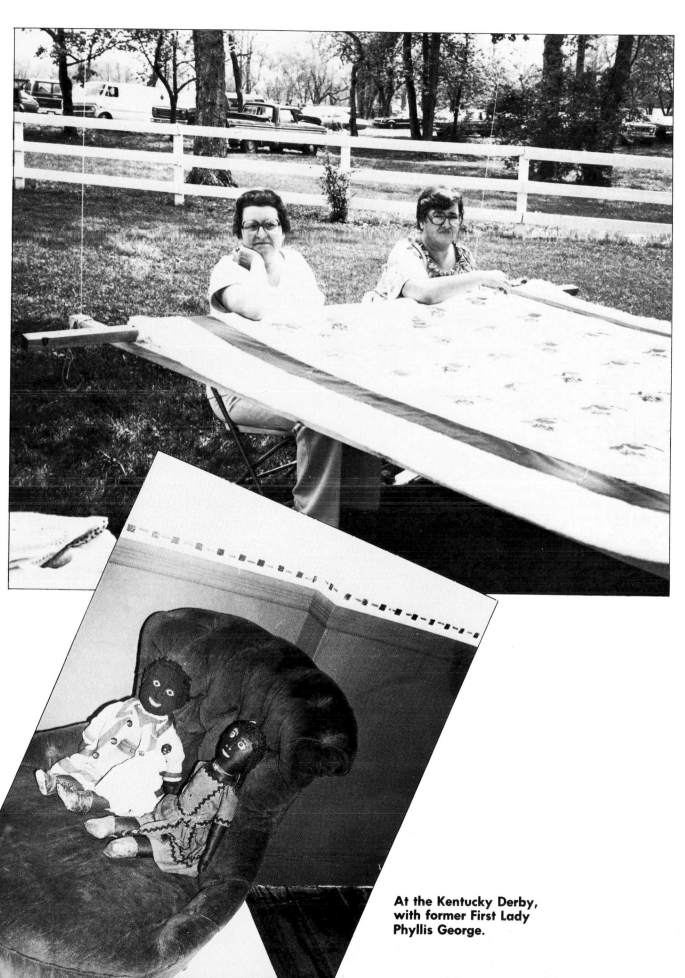

At the Kentucky Derby, with former First Lady Phyllis George.

TEXAS

Texas really is "the land of the free," because when a Texan gets money or power, they immediately go out and do whatever they've always wanted to do, and they never think about what other people might think or say about it. And they do it all in a big, big way.

But that bigness has two sides. In Houston, the city is so spread out that the police can't keep on top of it all, and the criminals and the con artists see all that space and think: unlimited opportunity.

I always thought cowboys looked like hustlers. That's nice. Cowboys and hustlers are quiet. They don't know many words.

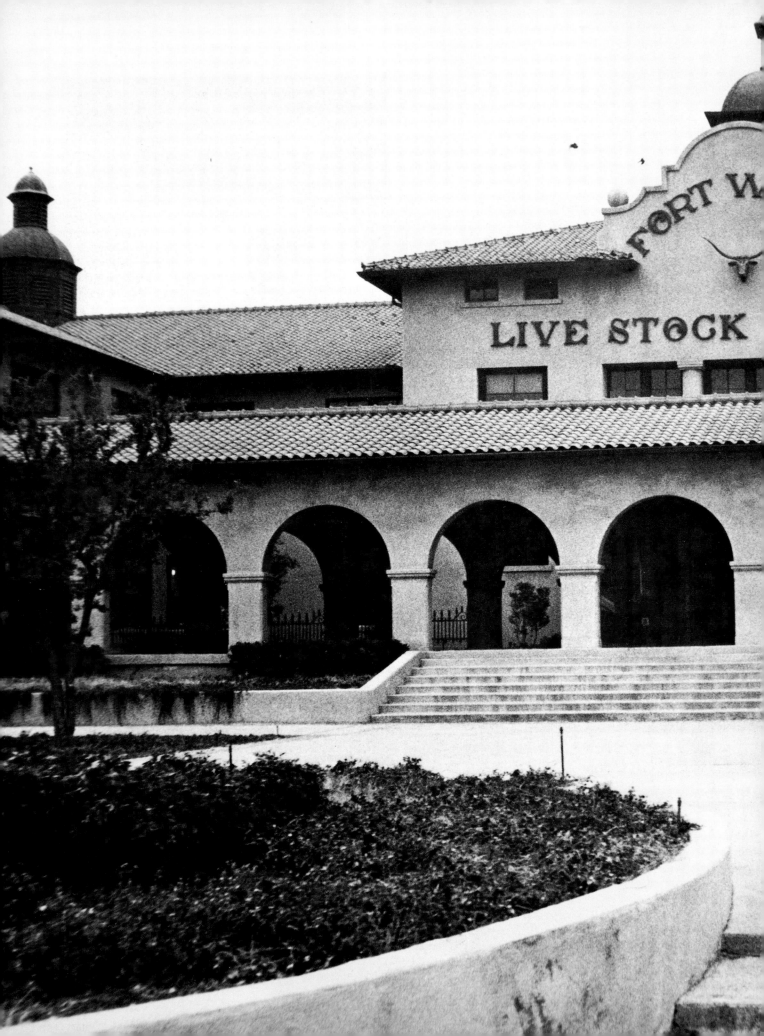

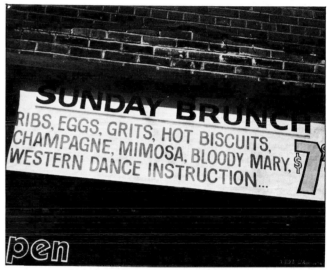

SUNDAY BRUNCH
RIBS, EGGS, GRITS, HOT BISCUITS,
CHAMPAGNE, MIMOSA, BLOODY MARY, $7
WESTERN DANCE INSTRUCTION...

pen

ASPEN

Land really is the best art.

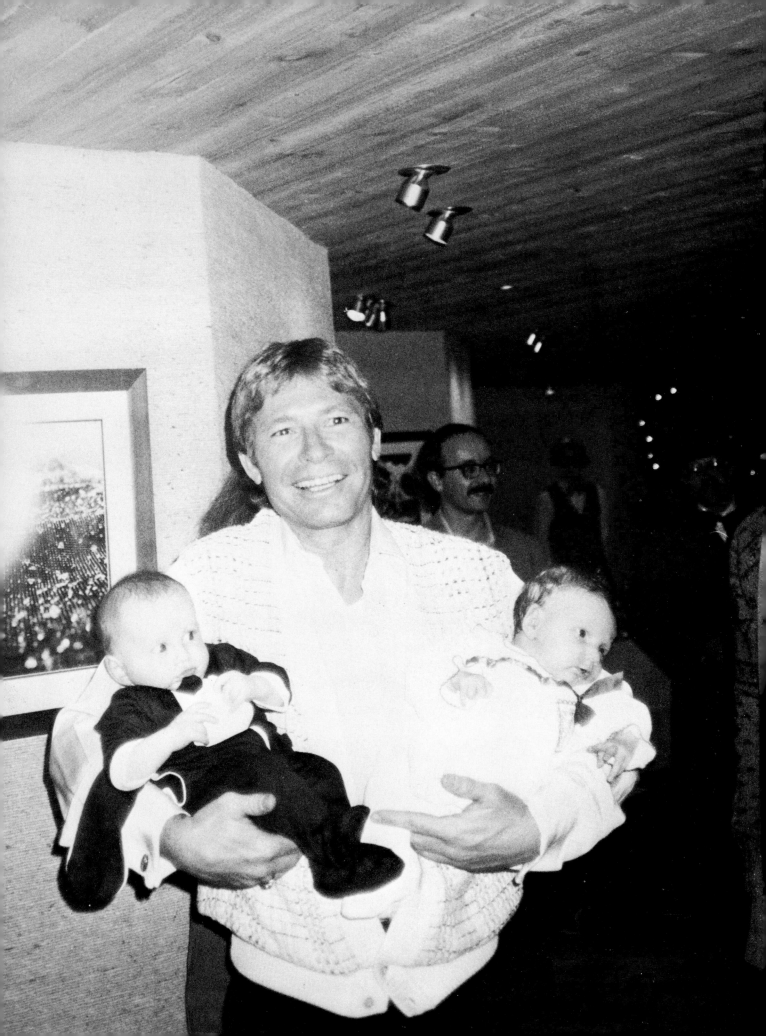

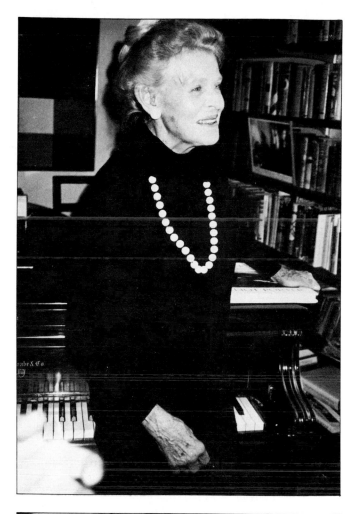

Aspen's John Denver.

In Aspen I met this beautiful lady in her eighties who looked like Katharine Hepburn. She said that when she first came to Aspen in the old days, a truck used to drive them halfway up the mountain, and then they'd get out and hike the rest of the way up with sealskins on their shoes so they wouldn't slip, and it'd take them all day to get to the top. And then they'd ski down. Once.

This is before the lifts.

When you leave the city and go out in the country you're always tempted to think, "This is the *real* America." The air smells so great and all the land with nothing on it looks so peaceful, and you remember all the wonderful things about being away from town with everything quiet and calm for a change.

Then you meet the people who live out in the country and you think, "These are the real Americans." They have the weathered faces like the pictures you've seen of the pioneers and those who first settled the West. They live in frame houses in the small towns that you've imagined as the backbone of America. And they have "real" jobs: mechanic, country doctor, fireman, plumber. And the farmers are living and working on farms just like in the movies with the rolling pasture and the red barns and the silver

silos and the grazing livestock. So you feel like their lives are somehow much more important and deeper than yours, and that you're missing some very important things by living in a city.

Then you start to learn more, if you get to stay for a while. Maybe one of the country people you meet is old with all their kids grown up and moved away, a wife that died some time ago, and they've spent more than a few years living out in the middle of nowhere, completely apart from everything else. They get to be like the city homeless in a way, because they aren't seeing enough of other people and they're starting to get a little nutty. And they get to know you better and they start to like you, so they tell you some of their ideas which they haven't spoken to anybody about in years, and the more you listen the more you realize this person is really crazy. Their thoughts have been bouncing around against each other with no outside opinions coming in, and their fantasies and what they think is happening outside of the world they know have turned completely nuts, just as nuts as the people you see on the streets of any city wandering around, talking to themselves out loud, and screaming for no reason.

The exact same thing can happen if you go out to the suburbs. You see the houses everywhere, the green lawns with the sprinklers, the jungle gyms in the backyards, the kids riding

their bikes to school, the mailman coming by with a smile, a woman unloading bags of groceries from her station wagon, and you can't help but think, "This is the real America." You imagine that everyone around who you haven't seen in a long time is living this very regular, humdrum life that's peaceful and the same thing day after day, and you think that everyone there is having a really easy time of it.

But then you start learning the details. You find out the nice man who always had an extra piece of gum to give you has gone completely off his rocker and killed his wife, that the ex-minister of the church you grew up in is now a big drunk who's totalled three cars. You learn that your best friend's parents who were always so great are getting a divorce, that the woman who you always thought was the most ordinary housewife ran off with another man to Canada. You find out that the girl you had a crush on in elementary school is now a religious fanatic living in India with a bald head.

So if you ever get a chance to travel around the rest of the country, you should try to do it, and especially you should try to stay for a while in each place and get a good look. Nobody in America has an ordinary life. And the *real* America is wherever you happen to be in the U.S. when you start wondering about the question.

CALIFORNIA

I once was at a Duchamp retrospective at the Pasadena Museum, and they served pink champagne at the party, which tasted so good I made the mistake of drinking a lot of it, and on the way home we had to pull over to the side of the road so I could throw up on the flora and fauna. In California, in the cool night air, you even felt healthy when you puked—it was so different from New York.

Tab Hunter should star in the movie of my life. People would be much happier imagining that I was as handsome as that. I mean, the real Bonnie and Clyde sure didn't look like Faye and Warren. Who wants the truth?

That's what show business is for, to prove that it's not what you are that counts, it's what they *think* you are.

It was always my dream to live in L.A. For a while, the movie studios were taking us out and talking about us coming to California and making movies for them, but nothing ever came of it. I guess we were just too weird and they couldn't understand it.

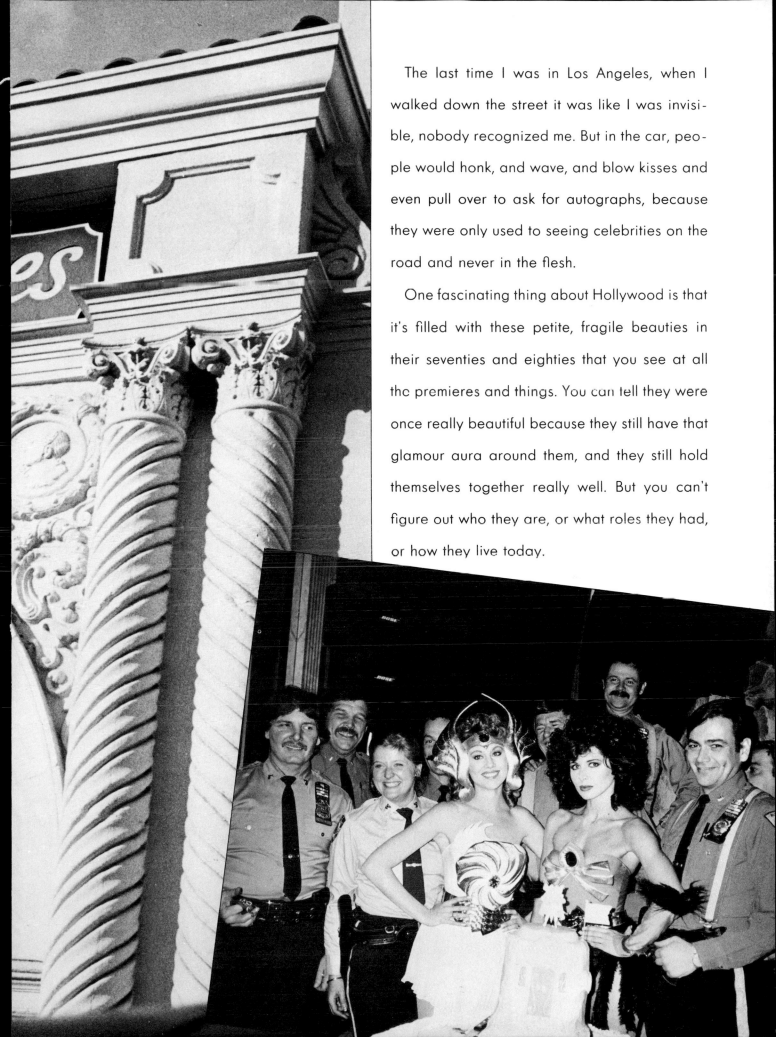

The last time I was in Los Angeles, when I walked down the street it was like I was invisible, nobody recognized me. But in the car, people would honk, and wave, and blow kisses and even pull over to ask for autographs, because they were only used to seeing celebrities on the road and never in the flesh.

One fascinating thing about Hollywood is that it's filled with these petite, fragile beauties in their seventies and eighties that you see at all the premieres and things. You can tell they were once really beautiful because they still have that glamour aura around them, and they still hold themselves together really well. But you can't figure out who they are, or what roles they had, or how they live today.

I mean if they were contract players, they didn't make much, so I guess they married really well. But even that doesn't explain it because there weren't community settlements then, you just went to Reno for a quick divorce and a nothing alimony, maybe $135 a month.

But they're all over the place and they look pretty good so I guess they're doing all right. They get invited to everything and they know how to look really grand, with the great old-fashioned jewelry and the "White Shoulders" cologne and the turbans and the Fabergé look, and the devoted fan who does everything for them.

One thing I miss is the time when America had big dreams about the future. You'd go to Disneyland and see this all-plastic house on stilts up in the air, and there'd be furniture built into the floor and moveable walls that would let you change your house every day if you wanted, and rooms that would completely clean themselves with robot vacuums. Or you'd go to the World's Fair and see a movie where the audience gets to vote on every step of the plot, and monorails that were completely silent but moved really fast. On TV they'd be saying that any time now we'd all be exploring out in space, and you kept waiting for when they'd ask who'd like to go to Mars.

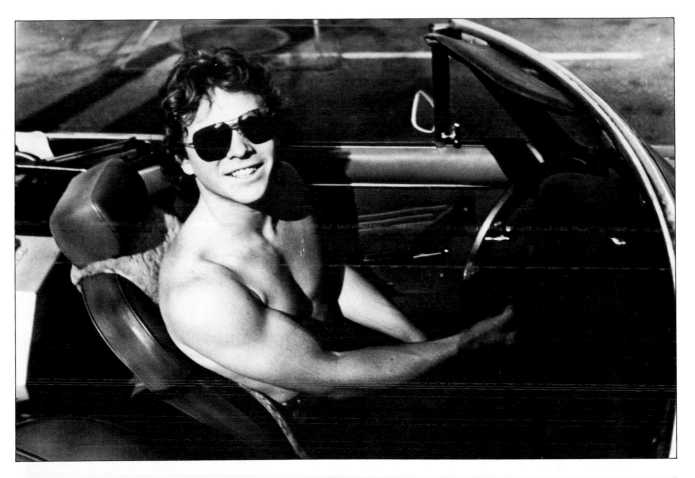

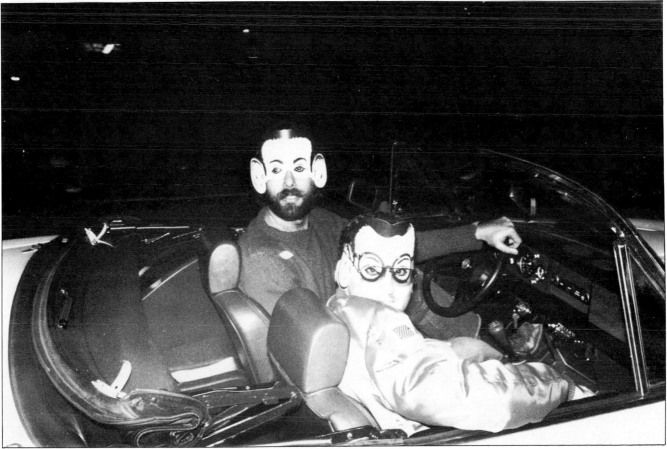

Every year there'd be a new scientific discovery or a new invention, and everyone would think the future was going to be even more wonderful than ever. This would make us all excited about America because we were the ones leading the world with these fantastic inventions and scientific discoveries, and we were going to be the first people to get to the future.

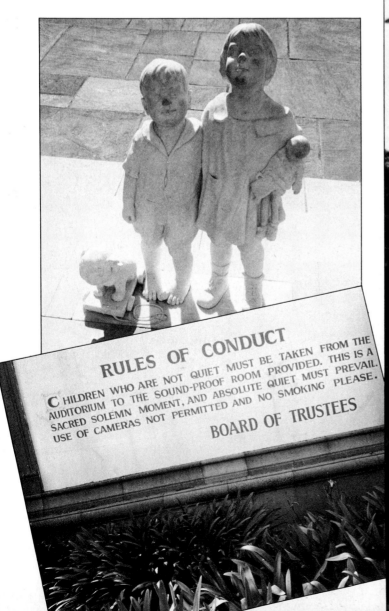

RULES OF CONDUCT

CHILDREN WHO ARE NOT QUIET MUST BE TAKEN FROM THE AUDITORIUM TO THE SOUND-PROOF ROOM PROVIDED. THIS IS A SACRED SOLEMN MOMENT, AND ABSOLUTE QUIET MUST PREVAIL. USE OF CAMERAS NOT PERMITTED AND NO SMOKING PLEASE.

BOARD OF TRUSTEES

Now it seems like nobody has big hopes for the future. We all seem to think that it's going to be just like it is now, only worse. But who's to say that this idea is any more realistic than dreaming about robots?

NATUR

I think there's a big difference today in what Americans think life has to offer.

When I was little I loved going to the movies and I probably hoped that the movies showed what life was like. But what they showed was so different from anything I knew about that I'm sure I never really believed it, even though it was probably nice to think that it was all true and that it would all happen to me some day.

Now, we have a whole generation and more who grew up watching TV, and TV is different. If you like a show, you watch it week after week, year after year, and I think that for kids of a certain age it's like learning something by having it drummed into their heads over and over. Even if what you're seeing on TV is completely different from everything you know, seeing the same shows and the same commercials must have some kind of effect on kids; it must make them believe, deep down inside, that it's true.

So now we've got all these people in their twenties and thirties with a part of them deep down inside looking for the real life they learned

about on TV. They think their own childhood and their own families are failures, because they don't measure up to TV children and families. They think that they deserve to have someone fall in love with them, someone who's like the kids on commercials: handsome, rich, creative, charming, always in love with you and about twenty-four years old.

People with television dreams are really disappointed with everything in their lives. They

I never met an animal I didn't like.

don't please their bosses and get promoted every other month like Darren did on "Bewitched," they don't have next-door neighbors who are fascinated by every little thing that happens to them, like the Mertzes on "I Love Lucy," and their day-to-day problems aren't a snap to take care of like they were on "Make Room for Daddy."

But some people have found a way to satisfy their TV dreams. They have pets, and having pets is just like having a television family. TV parents never have any real problems with their children, and owners don't have too much trouble with pets. Pets make a family that's always loyal, will do just about anything to make you happy, never criticize, love you till the end of the earth, and never expect much in return.

You can get a cat that calls to you every morning when you go out the door, just like a TV mother; a dog that always has that sad, cute face when you scold it, just like TV children; a pet that comes running to the door all excited just because you're coming home, like a TV wife; and one that sulks in the corner when it doesn't get its way, just like a TV husband or father.

Most of the time one pet can even do all these things. So even if you're sort of poor, but you have all these television hopes and dreams, pets are really the answer.

EDITOR

They guess that there are between 300,000 and two million people living on the streets in America.

A World War II hero froze to death in a park across the street from the White House.

This country is so rich. And I think I see more homeless people on the street every month.

How can we let this keep happening?

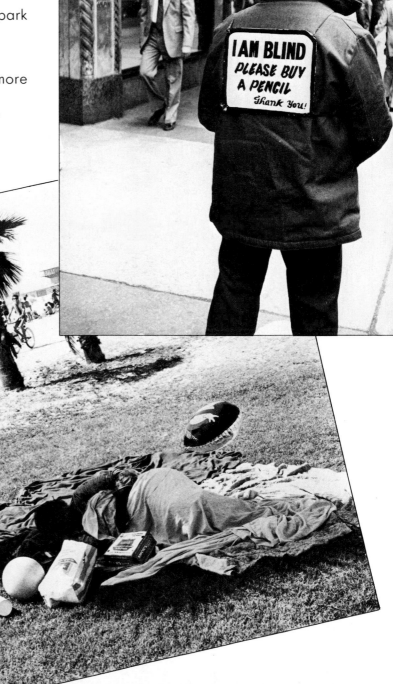

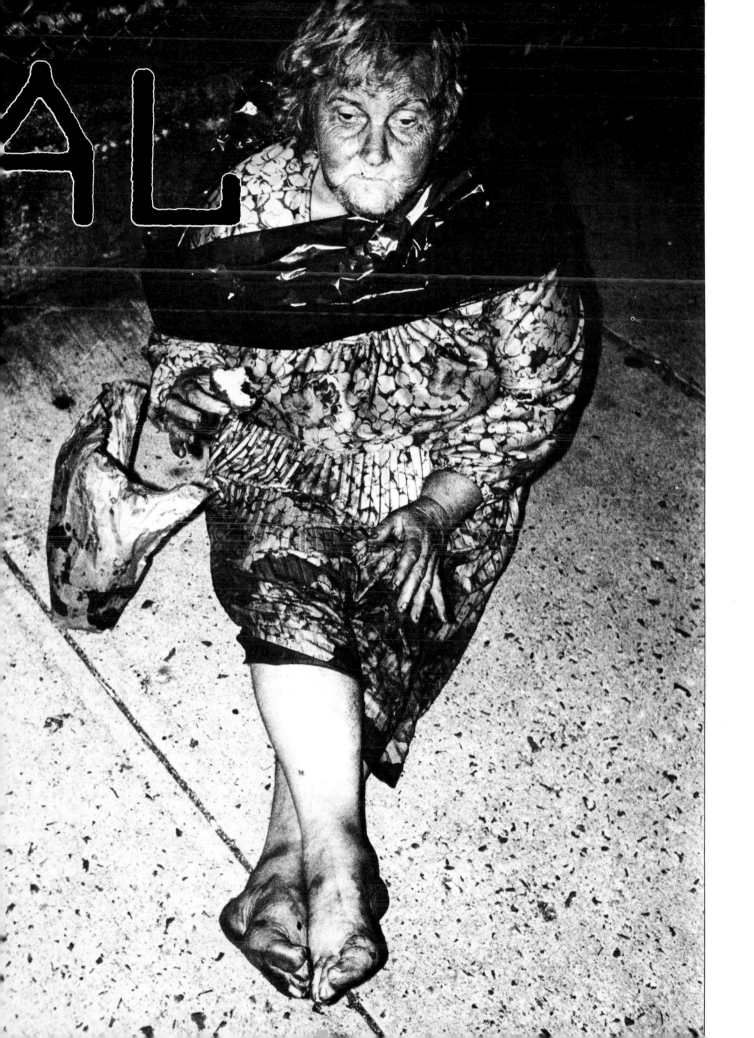

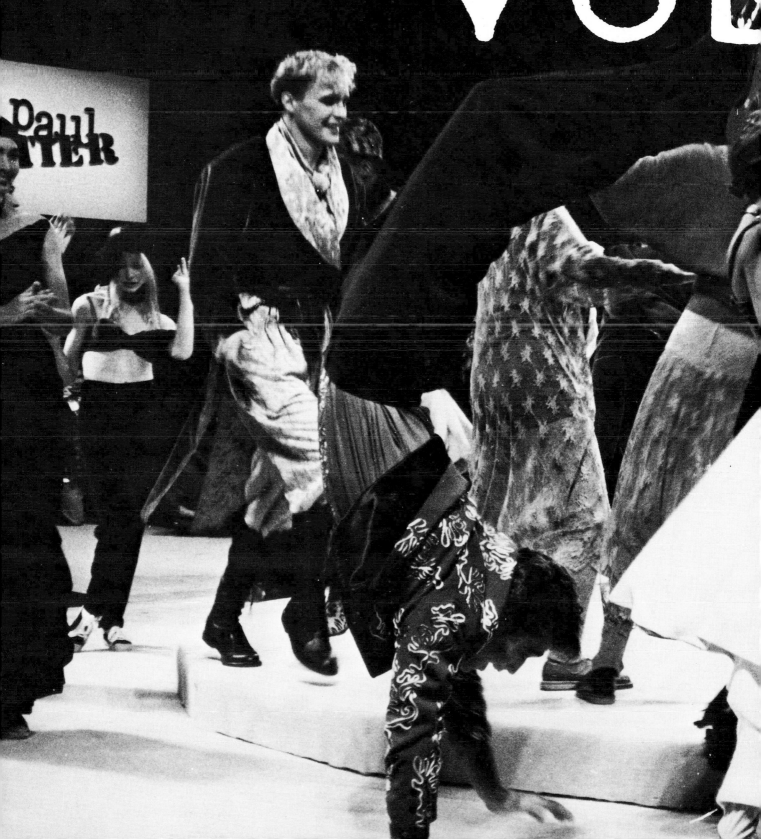

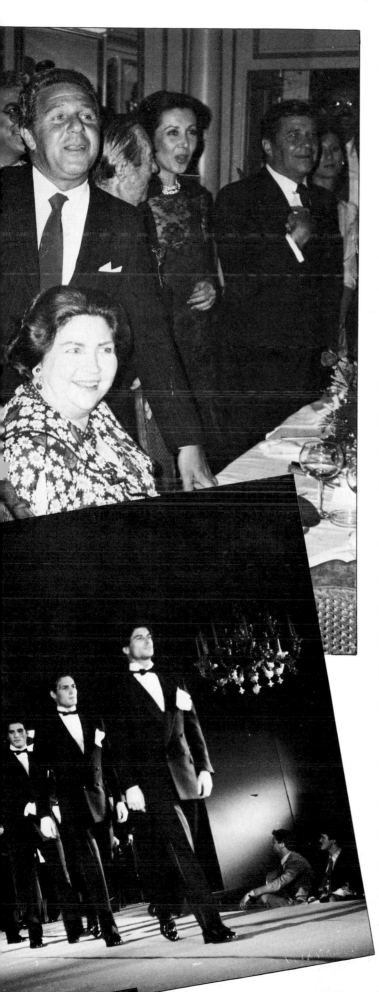

In America you either need money or style to live really well. Everything's here, and you can tap into it either by buying it or by convincing people to let you have it for free because you're great to look at and they want you around.

I see the same chic poor people night after night at the parties in New York. All you've got to do is look right and anybody will be happy to feed you, no questions asked. Some of these people live in one-room tenements and they have absolutely nothing. But they know how to buy cheap clothes that look great and they get jobs with expense accounts so, even though they may not have much income, they live like they've got a million bucks.

It's just like the comedies from the thirties where the poor young guy arrives in Gotham, showers, shaves, puts on a good suit, and goes out into Society to mingle and nobody can tell that he's not the heir to some fortune. He's intelligent and well-dressed and clean, so what's the difference?

It works on every level; just dress to mingle. You need one kind of look to get into the clubs that the kids go to, you need another to freeload at the Broadway opening night parties, and you need another for the sports parties. It takes a lot of work to figure out how to look so good they'll want you; it's easier to get a good job and *buy*

your way in, which is what most people do. But that's never been the chic way and, in reality, the clubs have more respect for those with style and they treat them much better than those who pay.

I've been reading that all the kids today are really conservative and America's taken this big shift, with all the high school kids clean-cut and dating without sex, and all the college kids trying to get into fraternities and giving up drugs for beer. Maybe this is sort of a good thing; the pendulum had swung too far and now it's moving a little back to make up. But then you also read about this really popular rock star who bites the heads off live chickens on stage. And you see Cyndi Lauper with her incredible hair and clothes and makeup being one of *Ms.*'s Women of the Year. And you go to the clubs and see kids doing and wearing crazier things than ever before.

So I wonder if all these sweeping trends that every magazine wants to be the first to plug into are sort of fake, that it's all just something you read about. Maybe the stranger people ran out of things to say so the press has to find someone else to interview. Or maybe it's that the magazines got tired of the wild stuff and started talking to the more normal kids because they were bored.

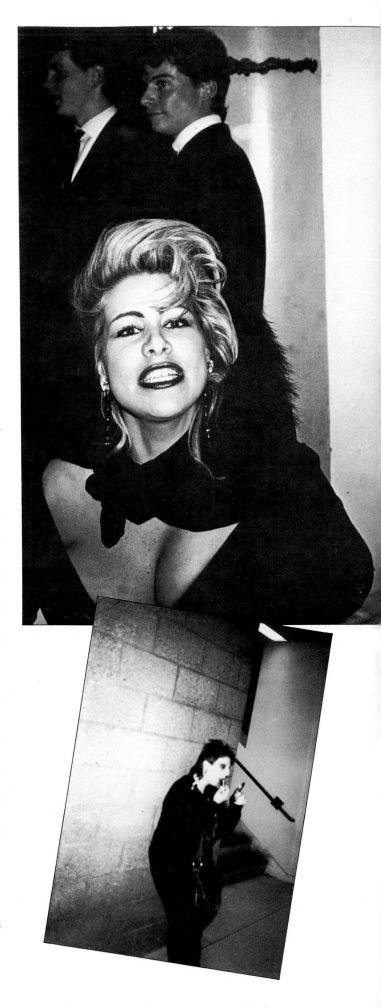

But whatever it is, America today seems to have more things going on than ever before. You used to go to a nightclub, and everyone would be wearing formal evening wear. A few years later, they'd all be in sweaters and slacks. Then a few years after that, they were in jeans and T-shirts, and then they finally wore the really wild sixties stuff. Now you see all of that, and even more, all at one nightclub. And there's sort of this competition going on in each group. The wild people try to out-wild each other with the craziest clothes, the conservatives see who can look the most businesslike. And the middle ones are out looking for who has the most interesting T-shirt.

Getting rich isn't as much fun as it used to be.

First the government takes away all the extra, and if you're in business you get in this cycle where every year you have to make more money—for the shareholders, or so the employees can get their raises. And you spend all your time thinking about making the payroll and moving the cash flow and knowing everything about tax laws which seem to change every year. And you only get off the grind by declaring bankruptcy—which is only just another kind of cycle.

Everyone dreams about inheriting big money, but those that do dream usually don't know

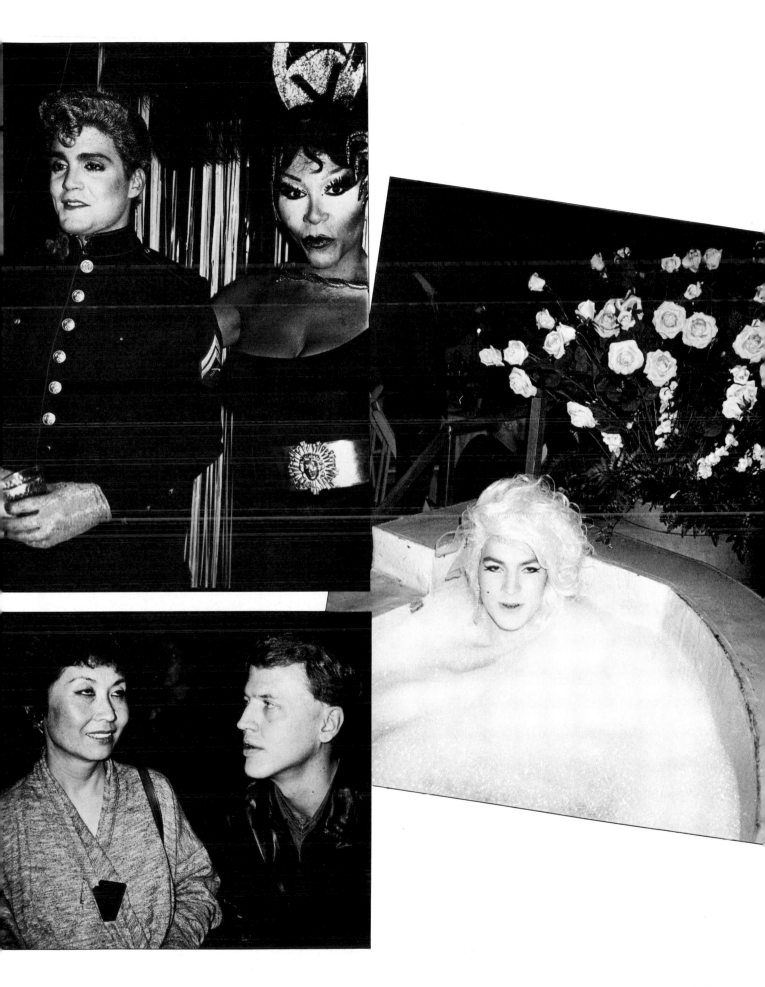

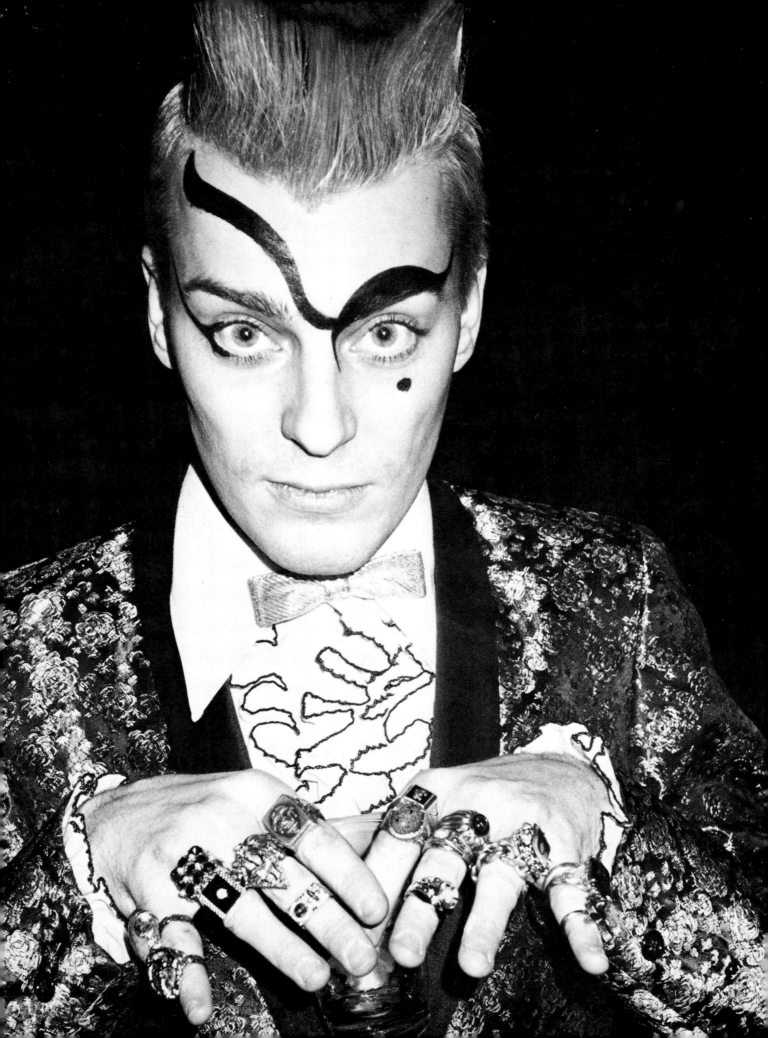

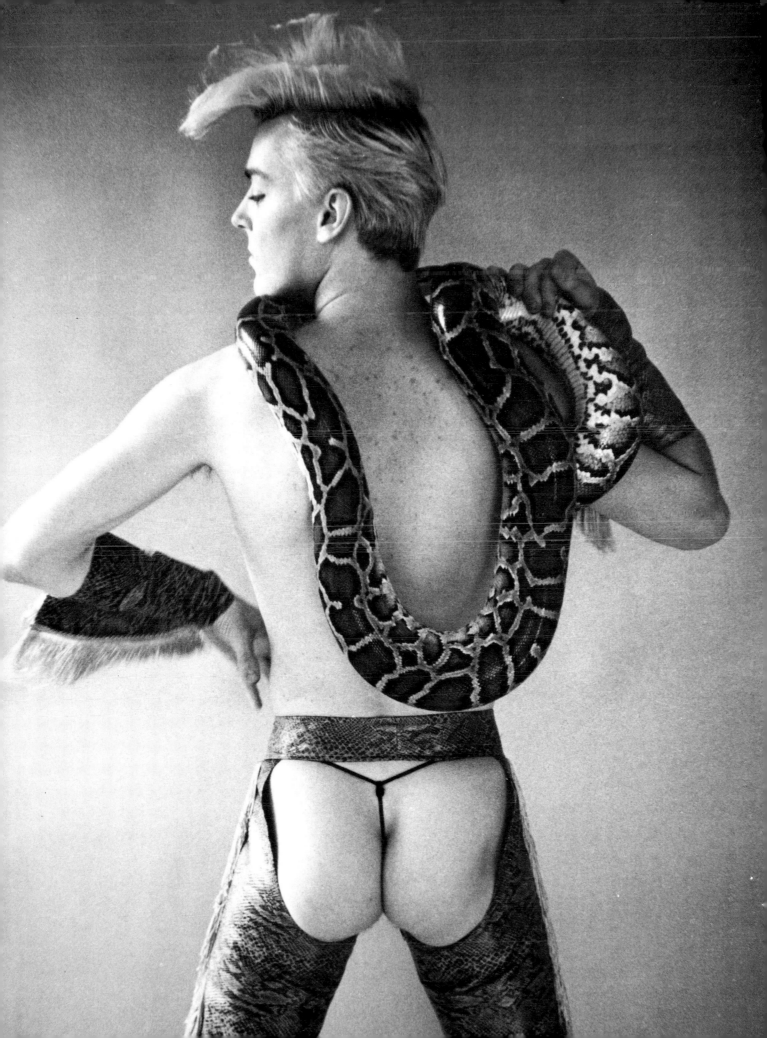

about the big problem: Trust Fund Syndrome. If you inherit so much money that you never have to work, what do you do? There's only so much TV and vacations and lunching around that anyone can take, so if you get the money and then get the syndrome, you wander around, thinking to yourself: Who am I? What should I do?

But having "old money"—that's great.

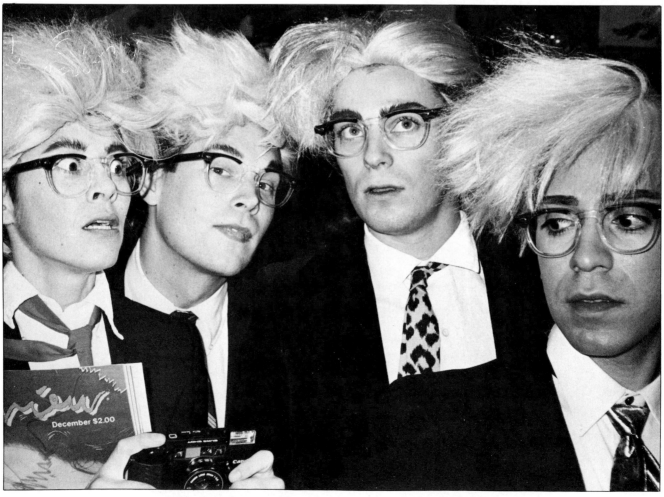

One thing that's fun is to see people with their "better half." You can think you know everything about somebody, and then you meet their girlfriend and you realize: I didn't know them at *all*. For the first time, you get to see the whole person with their secret, private life.

It's just like watching an actor take off his makeup.

The best way this works is when someone's trying to pull a snow job on you. They're bragging and they're telling these incredible stories, and you're really impressed. Then suddenly their boyfriend shows up, and he's this big creepo, and then the *real* story gets told.

Being single is best, but everyone wants to fall in love. I guess it's because they hear it on the radio and they've got to have it. But it seems to never work out, unless you know all about your "love league."

This girl who really gets around and always has the best guys told me about "love leagues." Or maybe I read it in a magazine. But what you do is look at yourself in four ways: face, body, money and power or prestige. Because these are the four things that make people fall in love. So you look at your own four things, and you give yourself ratings—terrific, medium or noth-

ing—but you have to be really honest and ob-jective.

Let's say you decide you have an OK face, a great body, medium money and no power or prestige. That means you should go after other people who also have two mediums, a terrific and a nothing. It's not supposed to matter which categories the different things fall in as long as it's two mediums, one terrific, one nothing. You could get a husband with a medium body, me-dium money, a terrific face and no prestige, or one with a medium face, medium power, a zero body and lots of money—whatever you're in-terested in, as long as the person's in the same "love league." And it should work out OK.

But if you're two mediums, a terrific and a nothing, and you go after someone who's four terrifics, or someone who's four nothings, it'll just be trouble and it'll never happen. I don't know if all of this makes any sense, but I'm sure some-one could turn it into a pretty good book and about twenty talk shows.

Also, how come personality isn't included in the "love leagues"? You used to always read that the best people were those with "personal-ity plus." I guess nowadays it takes too long to get to know someone's personality and you have to be able to decide fast whether some-one's worth your time and trouble.

People have come up to me and said, "You must be the *most* American artist," and I've read others who think I'm "un-American." Since all of us came from somewhere else—even the Indians came over from Asia a long time ago—I don't see where anybody can draw the line at being "more American," even though they always keep trying with ideas like "I must be more American than she is because my family came over on the Mayflower," or "I'm more American because I'm blonde and blue-eyed and live in the Midwest," or "We're more American than they are because we can speak English."

It used to be that we let anyone come to America who wanted to because we needed them to build the skyscrapers and the train tracks and do all the dirty work that the people who were already here didn't want to do. And now they say that with high unemployment we shouldn't be letting anybody else in, and we should kick out anyone who isn't here strictly legally.

But it seems to me that we're still having the immigrants do the work that "Americans" don't want to do. When I was in California I found out that people were learning Spanish so they could talk to their maids, and that all the people doing the really boring jobs in the electronics industry

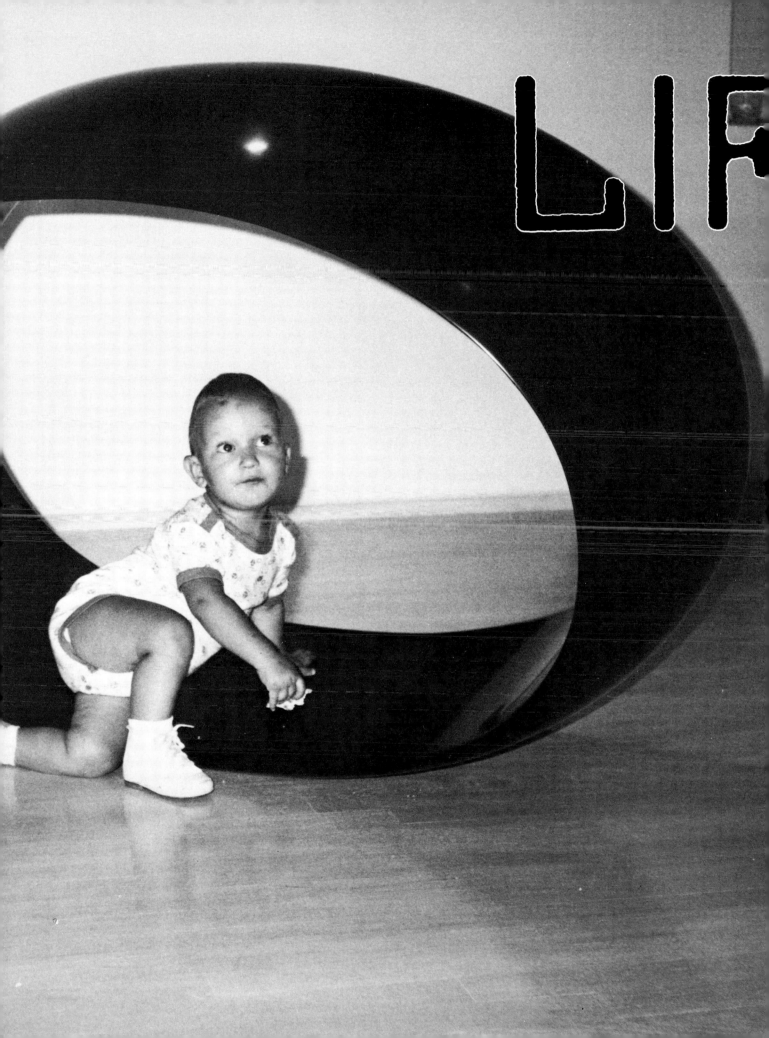

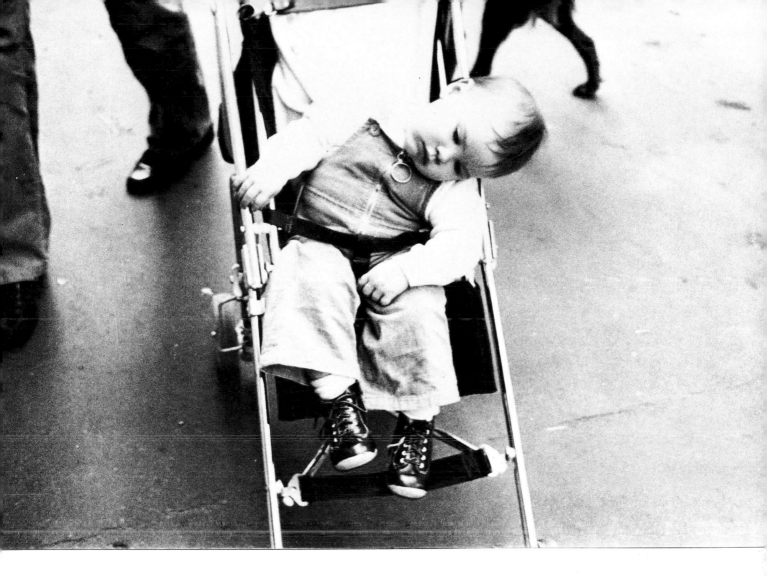

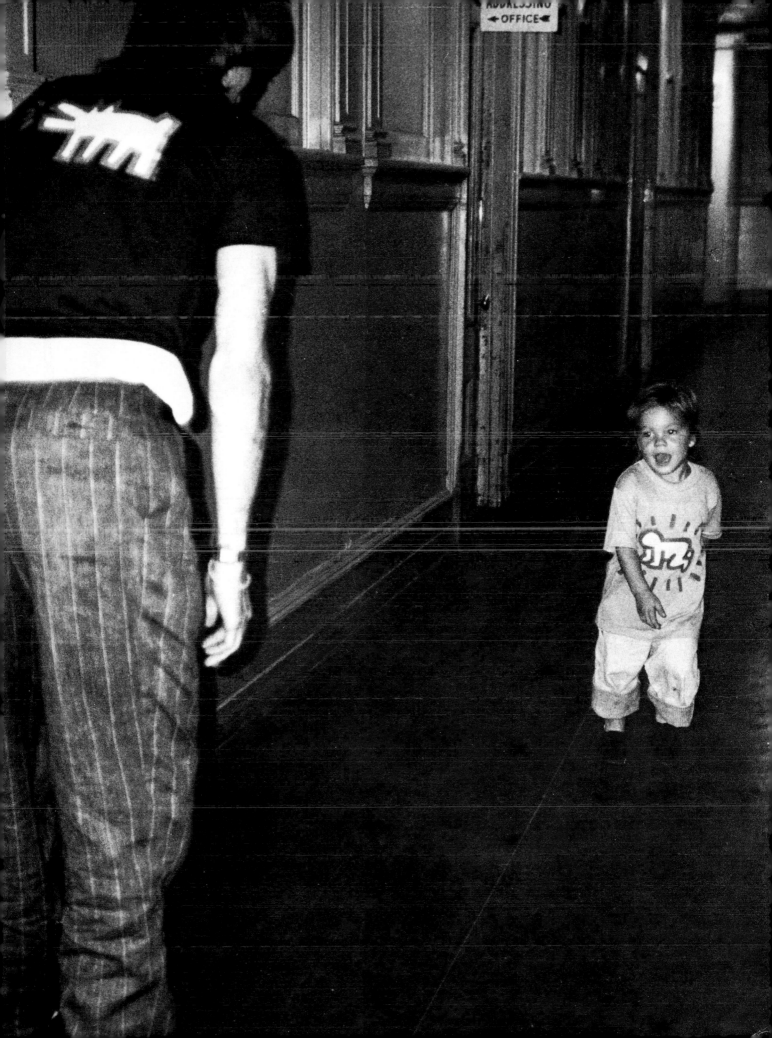

were immigrants. And if unemployment is so bad that we can't really afford the new people coming in, then why are all the maids Spanish, and how come there's a new Korean greengrocer opening in New York every month, and why do the Mexicans keep risking their lives and being thrown in jail to cross the border and get work in the U.S.?

I guess it's part of every country that if you're proud of where you live and think it's special, then you want to be special for living there, and you want to prove you're special by comparing yourself with other people. Or maybe you think it's so special that certain people shouldn't be allowed to live there, or if they do live there that they shouldn't say certain things or have certain ideas.

But this kind of thinking is exactly the opposite of what America means. We all came here from somewhere else, and everybody who wants to live in America and obey the law should be able to come too, and there's no such thing as being more or less American, just American.

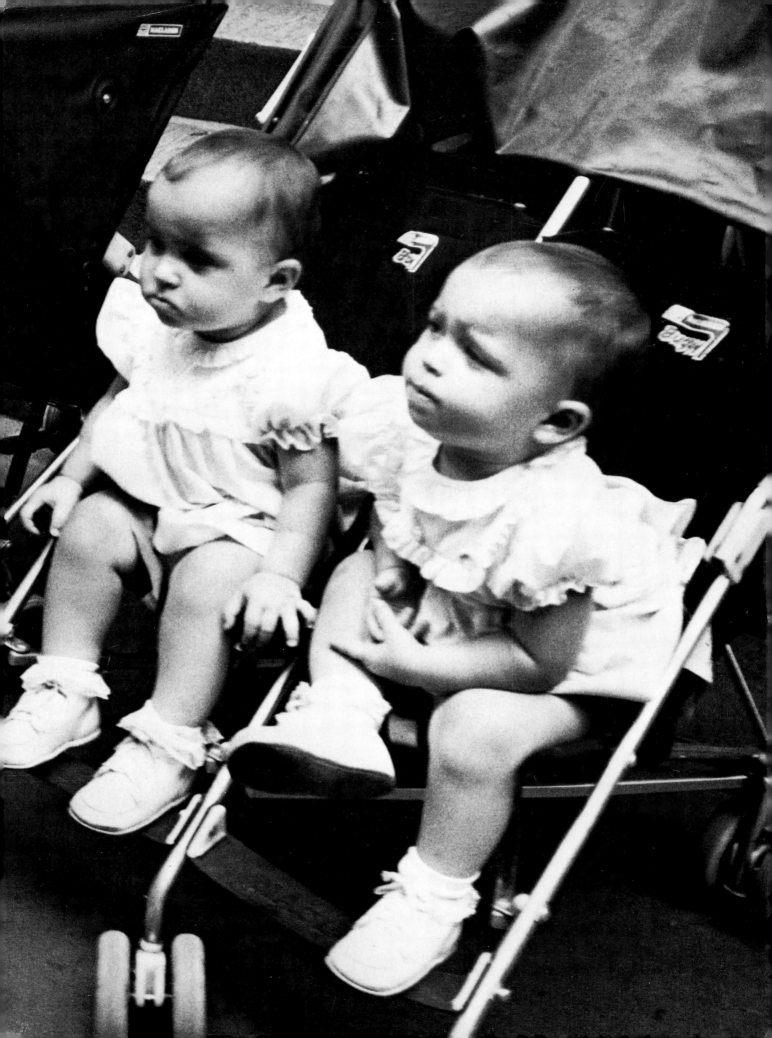